READ THIS IF YOU WANT TO BE INSTAGRAM FAMOUS.

W9-BYA-682

LAURENCE KING

Published in 2017 by
Laurence King Publishing Ltd
361–373 City Road
London EC1V 1LR
e-mail: enquiries@laurenceking.com
www.laurenceking.com

This book was designed and produced by
Laurence King Publishing Ltd, London.

A catalogue record for this book is available
from the British Library.
ISBN: 978-1-78067-967-9

Series editor: Henry Carroll
Research: Jess Angell – @MissUnderground
Design: Alexandre Coco

Printed in China

INTRODUCTION

So you want to be Instagram famous, eh?

STEP 1: Go to a cafe. **STEP 2:** Order a salad. Better still, order a salad with kale. **STEP 3:** Stand on your chair, take a picture and boom! You and your **#KALESALAD** will have yourselves a million followers and a new BFF called **@KYLIEJENNER.** It's that easy, right?

Wrong. There's way more to making it big on Instagram than that. You need to be passionate about your pictures and create a feed that's fresh and individual. Most of all, you need to be creative, original and strategic with your posts.

Behind every famous feed there's a super-savvy snapper who knows exactly what they're doing.

Here, 50 of the greats share their secrets to becoming Instagram famous in their own words. Their insider knowledge covers everything from perfecting your photography skills and developing your personal style to interacting with the community and attracting brands. You'll learn how fashion and fitness icons like **@DANIELLEPEAZER** managed to clear the million mark. You'll find out how **@TASTEOFSTREEP** amassed over 100,000 followers in a matter of weeks. You'll know how to become famous for food like **@SYMMETRYBREAKFAST** and speak the language of lifestyle like **@HELLOEMILIE**.

No matter what direction you want to take your feed in, this priceless advice means you can build a following fast, create something to be really proud of and, of course, give up your day job, travel the world and get shit for free.

@DANIELLEPEAZER
Danielle Peazer
Followers: > 1.2m

Inspiring feeds:
@eimearvarianbarry
@sincerelyjules
@victoriametaxas

Mix business with pleasure

People connect with pictures they can relate to. So, in order for your account to grow, ensure you have an even split of personal and business pictures (which may or may not be sponsored). If you have an emerging account, tagging airlines and hotels is a good way to expand your business contacts. If you're on holiday, let people know what brands you're wearing while out and about exploring. I try to give a personal feel to any paid posts by working with clients to create good content that we are both happy with. You know best what images you and your followers will connect with.

Danielle's story

I created my account in 2012 out of curiosity. After a while, some of my followers started to ask where my outfits were from and for advice on what to wear, which was when I decided to think seriously about it becoming a job. I think people like the mixture of professional photos and photos of me socializing with friends. I only work with brands I genuinely like as, for me, it's more important to be authentic than just to earn money.

See the light

Changing light opens up new perspectives on familiar scenes. I often feel that I have photographed everything in my city and yet, depending on the conditions, light can give the same place a completely different look. Don't just visit a location once. Go back at different times on different days during different seasons. That's when you'll start posting shots that people love.

Thomas's story

When I downloaded Instagram back in 2010 I was just looking for an app that would allow me to share some funny snaps with a friend. I could never have imagined how much my life would change because of that download. I quickly discovered a deep passion for photography, which has now become my day job. Instagram also totally changed the way I travel. No matter where I go there's always someone to have a coffee with or to show me around. For me, this is the most valuable thing of all.

@THOMAS_K
Thomas Kakareko
Followers: > 655k

Inspiring feeds:
@cirkeline
@sionfullana
@koci

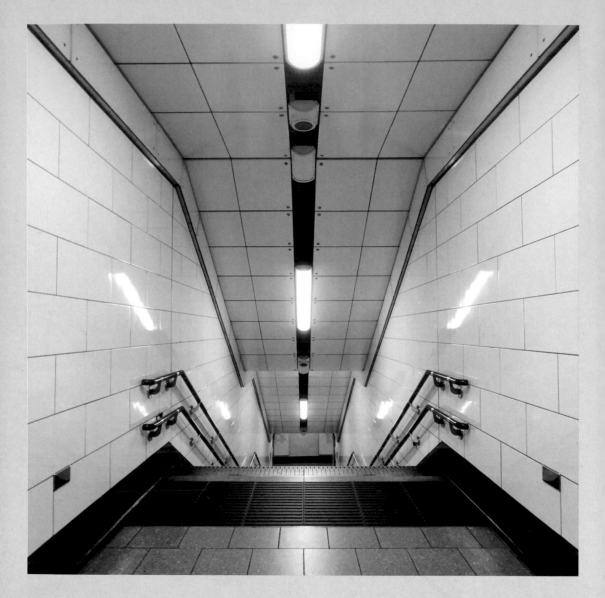

@MISSUNDERGROUND
Jess Angell
Followers: > 50k

Inspiring feeds:
@mrwhisper
@13thwitness
@underground_nyc

Look for the lines

Look for different angles when taking your photographs.
Holding your camera or smartphone up high or down low opens
up different angles to play with. Look for striking lines to pull the
viewer into your photograph – walls, the stairs or even handrails.
Lines that extend in from the edge of the frame can be a strong
visual pull. If you like geometric images, remember to hold your
camera straight and flat in relation to your subject so that the
angles don't get distorted.

Jess's story

In 2012 I created **@MISSUNDERGROUND** solely to feature my images
of the London Underground, which I've always loved. A turning
point for me was being featured on the Instagram blog in 2013,
when I went from 8k to 24k followers in one day. Capturing the
escalators, tunnels and spaces in the Underground in their
simplest, most symmetrical forms has now become an obsession.
I try to photograph the Underground every day but sometimes
there are too many humans around!

Keep it the same but different

It's important that your account has a consistent feel to it, both in the colours you use and the content you share. This gives you an identity that people will instantly recognize when scrolling through their feed. While it's tempting to try out different effects and filters, try to stick to the same apps and editing tools. I tend to steer clear of filters, preferring to brighten my images and adjust the contrast, shadows and warmth using PicTapGo. If you like the minimal look, think about how your pictures will appear next to each other. Compositionally, I'll leave an area of plain colour around my busier images, allowing them a bit of breathing space.

@CAROLINE_SOUTH
Caroline South
Followers: > 100k

Inspiring feeds:
@5ftinf
@pchyburrs
@spielkkind

Caroline's story

I have always loved creating mementos – taking photos of my family, collecting treasures and crafting with natural and found objects. I spend lots of time beachcombing for things to photograph and share. Initially I shared these through my blog, but found Instagram to be more instant, with less need for lots of accompanying text. I then was lucky enough to be included on Instagram's list of suggested users, which increased my following further. Sharing photos on Instagram has become part of my everyday routine, allowing me to take a moment for myself, away from my busy family and work life.

@SERJIOS
Serge Najjar
Followers: > 75k

Inspiring feeds:
@janske
@joseluisbarcia
@kristinenor

Train your eye

The best advice I have is to train your eye. Start by looking at your neighbourhood in a fresh way. Try to see the hidden details, capture the changing light and look for moments when people become significant in a space. Hashtags are not really something I use. Focus on the photography and avoid anything that speaks louder than the picture itself (like too many hashtags).
My pictures all have a title but that's the maximum I allow myself to add.

Serge's story
Born in Beirut, Lebanon, I am a practising lawyer and a doctor of law. I started publishing my photographs on Instagram in 2011 and was soon contacted by a number of galleries (I have shown my work through Galerie Tanit since 2012). I was the winner of Photomed Liban 2014 and my works continue to be exhibited at international fairs such as Paris Photo. Since the beginning, I have tried to show through my Instagram account how thin the line is between the ordinary and the extraordinary. By looking at things around us with an inventive eye, I believe we bring the ordinary closer to art.

Unleash your inner weirdo

Don't worry about what other people will think. Make something for yourself – do what you think is funny and don't alter your vision or stifle your instincts to fit in. I'd love to say I had a master plan but I started my account for my friends and I'm still in a state of shock over how popular it has become. My account came out of left field and that's why it's attracted so much attention so quickly. In hindsight, I guess it's all about being different.

Samantha's story

I am a 25-year-old actor, illustrator and graphic designer from south Florida, currently living in Brooklyn. I am not sure why I started the Instagram account. One day I found this great pink photograph of Meryl Streep from the movie *She Devil* and felt inclined to put her on top of a strawberry-frosted doughnut. That was in November 2015 and about two months later I woke up one morning and decided to make an entire account dedicated to Meryl Streep and food. I have been contacted by a few snack brands amid all the 'viral insanity' – and I never say no to free food.

@TASTEOFSTREEP
Samantha Raye Hoecherl
Followers: > 115k

Inspiring feeds:
@bethhoeckel
@officialseanpenn
@pipnpop

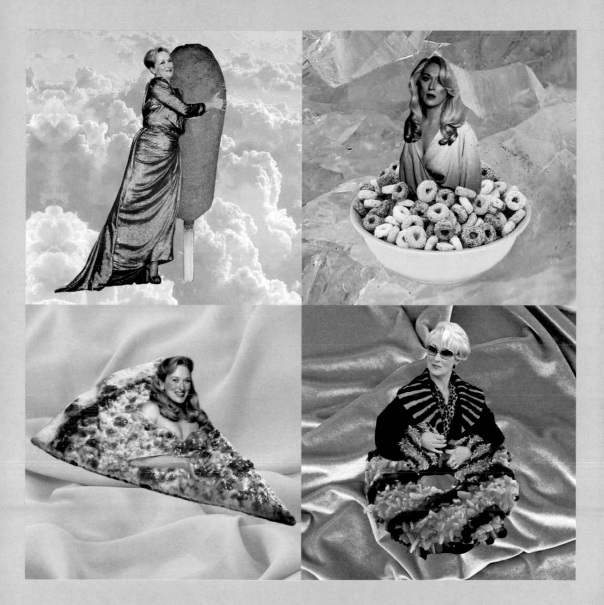

@BERLINSTAGRAM
Michael Schulz
Followers: > 460k

Inspiring feeds:
@ecolephoto
@efi_o
@mr_sunset

It's all in a name

If you're new to Instagram I would advise you to check if your account name of choice is available on other networks like Snapchat, Facebook, Twitter and Tumblr. Instagram is just one platform and you get way more engagement if you allow your different channels to feed off each other. Having a consistent name makes it easier for your followers to find you. Picking a relevant name is important, too. My name, **@BERLINSTAGRAM**, got me more attention as people knew what to expect: Berlin photos! Nowadays I occasionally feel that my name limits me a little – I'm travelling more and people sometimes say 'That's not Berlin' – but followers do understand that accounts need to grow and evolve.

Michael's story

I downloaded Instagram two weeks after it was published, in autumn 2010. I didn't use it, however, until I discovered photo-editing apps. Being able to shoot thousands of photos at no cost fascinated me. My photos from those early days now look funny to me: bad filters, low resolution, weird compositions. I quit my advertising job two years ago and now combine that experience with my Instagram expertise to make a living from consulting for brands, creating campaigns and producing content. I think that smartphones and photo-editing apps were the democratization of photography, and Instagram is its social engine.

Perfect your profile

First, you need to set up your account, or tweak your existing one, to make sure everything is just right. Depending on the purpose of your account, you're going to need to think about some essentials so you give off the right vibe and max on engagement.

Your handle

It's important that this suits your account as this will often be the first impression you create. Ideally you want something catchy and relevant, but you're going to need to be creative as any really obvious names will already have been snapped up – **@BERLINSTAGRAM** is a good example of this (see p.20). If your name isn't available, try options with underscores. These are also a good way to separate out words for clarity, such as **@ME_AND_ ORLA** (see p.50). The shorter your name the better, as some platforms have a character limit.

Your picture

This is basically your logo, so use something clear and instantly recognizable. Avoid overly cluttered compositions as details will get lost in such a small image. If you're showing your face, think about whether you're smiling or serious, as this instantly sets the tone of your account.

Your bio

Unless you want to stay anonymous, like **@BREADFACEBLOG** (see p.42), putting your full name in your bio makes you seem more approachable. Try to sum up your essential information in as few words as possible. Emoticons are a good way to save space and also add a bit of personality. English is the most used language on Instagram, so if you're looking to attract a global audience use both English and your native language.

Added extras

If you're actively trying to attract enquires, then definitely include an email address. Set up an email account specifically for your Instagram, because as your account grows you'll attract spam. Likewise, link to your website, blog or other social channels like Snapchat to increase your traffic. It's also good to show brands that you have other active platforms. Always remember to keep this information as up to date as possible.

Start following

If people like your account they'll check out who you're following to find similar accounts. Who you choose to follow is an extension of your bio, as it shows your interests. Don't frivolously follow everyone, especially when you start out, because your feed will fill up with junk and your Instagram identity will become a little undefined.

Prime examples

Of course, all our crafty contributors know exactly how to make an effective profile. Here are some that stand out for different reasons. Follow their lead!

daniellepeazer

Danielle Dance/Fitness, Travel, Fashion, Life
rlpeazer @DaniellePeazer @reebokwoman
WATCH my new video youtu.be/47vAKJhpijo

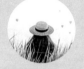

helloemilie

Emilie Ristevski Forever wandering with a camera in my hand. Currently in @tasmania | Snapchat > goodbyeemilie
info@helloemilie.com | **facebook.com/helloemilie**

ihavethisthingwithfloors

I Have This Thing With Floors When nice feet meet nice floors. Take a selfoot. #ihavethisthingwithfloors • Curated from Amsterdam
facebook.com/ihavethisthingwithfloors

tasteofstreep

taste of streep because what more could you want?
tasteofstreep@gmail.com Brooklyn, NY

Comment with care

Comments are the most caring way to interact with your Instagram community. I treasure any comments I receive, and I take the time to make meaningful comments on other people's feeds. If you love a picture, tell that person! Likewise, if someone comments on your picture, reply with feedback on their feed rather than a generic thank you. I find that this approach builds a stronger relationship with followers; a thank you is kind but not as meaningful.

Valentina's story

After giving birth to my second child and moving to Hong Kong as a stay-at-home mum, I was looking for inspiration. In 2012 I tried something new every month and, after failing miserably at drawing, I got hooked on Instagram. I discovered a love for photography, and getting feedback, inspiration and encouragement on a daily basis was a game-changer. I can now call myself a photographer and, even though it's a career I only just started, it feels so right and fulfilling.

@THATSVAL
Valentina Loffredo
Followers: > 75k

Inspiring feeds:
@cimkedi
@omniamundamundis
@serjios

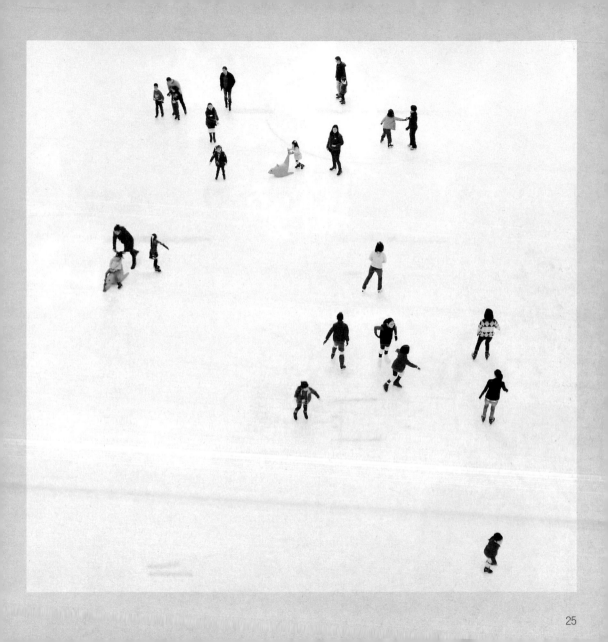

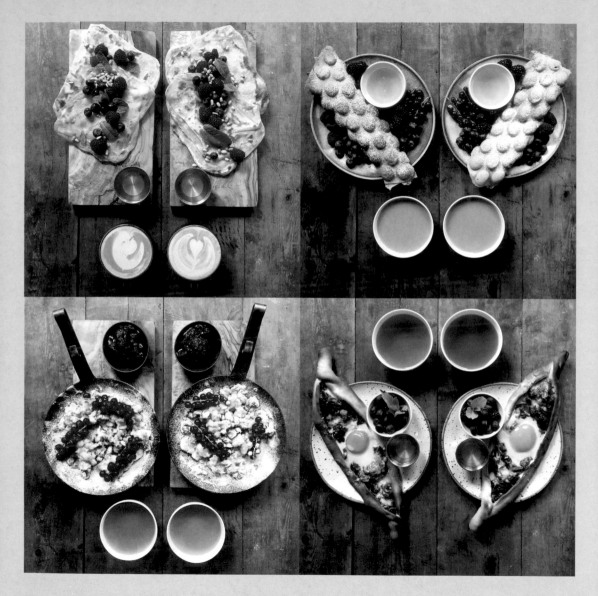

@SYMMETRYBREAKFAST
Michael Zee
Followers: > 600k

Inspiring feeds:
@palestineonaplate
@thecuriouspear
@raretealady

Stay focused

You can't cover every single subject or style on Instagram, so don't try. Focus on a subject or style that you love, but within that, research it using everything you can get your hands on. Visit museums, watch films, read books, look at the work of designers, photographers and artists – not just living, but historical too. Become an expert on your chosen subject, and then others will come to you for inspiration and advice. Be flexible and evolve, but stay focused on your Instagram theme.

Michael's story

I created **@SYMMETRYBREAKFAST** for my partner, Mark, in 2013. My passion for cooking comes from my parents and my English, Scottish and Chinese heritage. Weekends and school holidays were spent working in my father's fish and chip shops, and I taught myself to bake because my mother had a sweet tooth. Mark has a hectic job so breakfast is a sacred moment for us, and it's my mission to make each meal as celebratory as possible. Over 800 breakfasts later, I still wake up early to make breakfast for Mark.

Break out

Try to capture people's curiosity by doing something they're not used to seeing. I did it by going against the norm with handwritten words posted on a platform that was made specifically for pictures. When you're creating content, don't get caught up in the question of how many likes and followers you'll get. Instead, find your voice and establish yourself as a leader of what you want to share. Everything else will then come because people will see a part of themselves in your posts. There are always people listening for something new. That's the audience you want.

Euzcil's story

On the surface, **@SATIREGRAM** makes fun of the typical Instagram user's behaviour. At its core, though, it's a reflection of how we use social media. Almost everything an individual posts on social media is an attempt to control how they are perceived – it's their 'highlight reel', their 'curated self'. **@SATIREGRAM** shines a light on the uncurated self, the real person behind the camera and what their intentions probably were before the moment of capture. I don't care much about likes, followers or fame – I do this for the art and because it makes people laugh at themselves. I hope my posts inspire people to capture moments that not even I can describe on paper.

no filter close-up of my duckface

@SATIREGRAM
Euzcil Castaneto
Followers: > 150k

Inspiring feeds:
@brooklyncartoons
@_eavesdropper
@thewriting

a picture of my breakfast.

a picture of a salad I'm having for dinner. I made sure to crop out the big bottle of ranch dressing that I'm going to pour all over this plate...

a cliché picture of an airplane wing through the window because I'm flying somewhere.

mirror selfie at the gym to show off my new workout outfit...

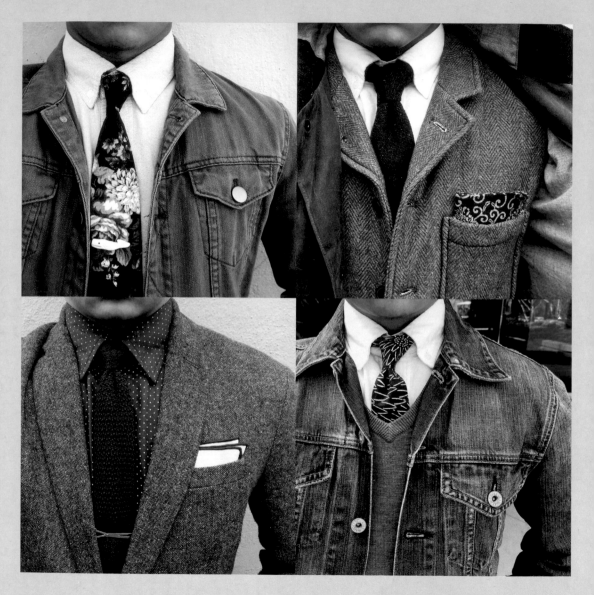

@THEDRESSEDCHEST
Rainier Jonn Pazcoguin
Followers: > 160k

Inspiring feeds:
@brothersandcraft
@fmuytjens
@theparcman82

Be honest. Be distinctive.

I think it's very important to be as genuine as possible. People can often tell when someone is just posting content for followers rather than displaying a genuine passion. I think some of the honesty and distinctiveness of my account, compared with other fashion accounts, comes from the fact that I really value anonymity. I'm not the most handsome guy, and focusing on the clothes allows my followers to better imagine themselves wearing the outfits. If you have a great idea and really care about what you're posting, then people who share your interests are sure to find you.

Rainier's story

I started my Instagram account in early 2014, both so I could keep track of what I wear every day and so that I could present my outfits to people who would appreciate them. I'm a software engineer by day and my combinations often went unnoticed. The greatest thing about my account is that it gives me – an otherwise average programmer – the opportunity to take on a whole new persona.

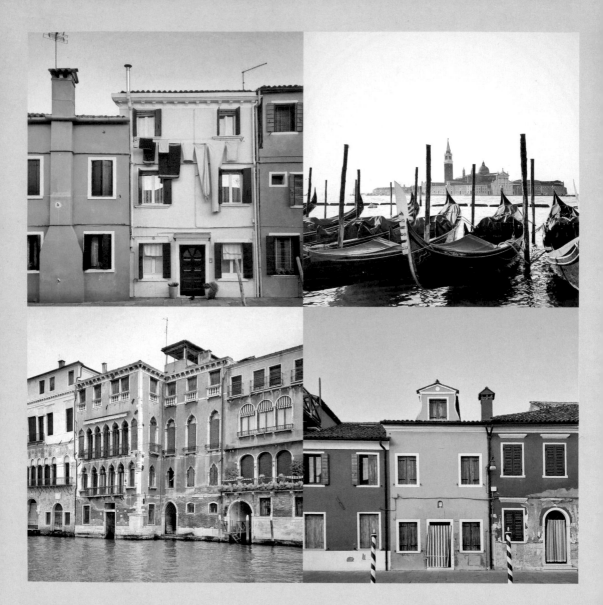

@GMATEUS
Gabriela Mateus
Followers: > 200k

Inspiring feeds:
@dansmoe
@brahmino
@nicanorgarcia

Make a mini-series

Find common links so you can create a mini photo-series. Your series could be about a particular place or a trip, or it could be held together by a theme or a colour palette. This will make your feed more compelling, as people will want to see where your story will take them. Writing witty or intriguing captions helps create a narrative too, and it also allows you to share your feelings and thoughts with your followers. Write a curious fact and ask questions to generate more engagement. For example, do you know why the houses in this mini-series I shot in Venice are painted such bright colours? It was so the fishermen could recognize them through the fog when they returned home!

Gabriela's story

I started my Instagram account to share important moments with friends. However, when I started posting less personal moments and simply sharing the joy that travel gives me, my follower count kept growing and growing. I was lucky enough to have been a suggested user by Instagram several times, which also helped. My educational background is in social sciences and I was also trained as a professional photographer but, in reality, taking pictures is still a hobby to me, and one that gives me so much joy.

Take poppers

The key to making an image work on Instagram is to make it immediately striking. If a photo doesn't have impact straight away the viewer will just carry on scrolling to the next one in their feed. A well-composed image will have immediate 'pop' and stop them in their tracks. Learning some basic compositional techniques – especially related to the square frame – makes all the difference.

Tim's story

As an art teacher I'm always looking for exciting new creative outlets, and Instagram launched just as I was becoming interested in photography. I first began working with brands while living in the Middle East in 2012. There were very few social-media photographers living there then, which led to my account receiving attention. Five years later, Instagram has afforded me many new opportunities. Offers of work and invitations to link up with fellow users have meant that I've been lucky enough to travel. I often reflect on how strange it is that a little iPhone app can change your life so much.

@THE.HAT
Tim Hatton
Followers: > 80k

Inspiring feeds:
@kitkat_ch
@le_blanc
@twheat

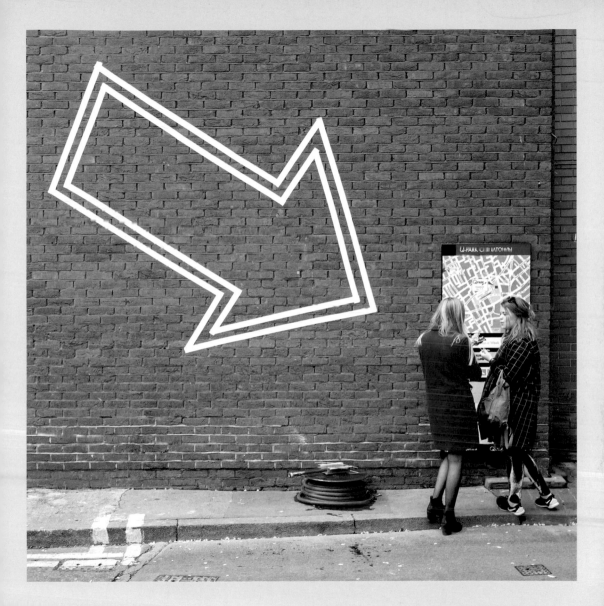

Stay composed

As **@THE.HAT** just mentioned, you can't afford to be sloppy with composition. Think of it like this. Here are two sentences: *'Composition is important because it guides the viewer around your image.'* And, *'Around guides important composition is because viewer your the it image.'* Both sentences are made up of the same words, but one is clear and the other is a jumble. It's the same when you make an image. How do you order what you're seeing to make a coherent picture? Here are some essential compositional secrets to save your images from drowning in the hashtag sea of wannabe thumbnails.

Lines

Look for lines that lead the viewer into your image. These could be roads, architectural features or a series of well-placed objects – anything!

@BERLINSTAGRAM

Foreground interest

Another way to lead the viewer into your image is to make sure you have something in the immediate foreground.

@OVUNNO

Rule of thirds

Rather than positioning subjects in the centre, create balance by placing them a third of the way into your frame. Use the grid view in 'Adjust' if you need help.

@PANYREK

Keep it clean

Make sure there's clean space behind your subject so it stands out. Don't be lazy – move them or yourself if necessary.

@DANIEL_ERNST

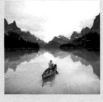

Framing

Draw attention to a subject by framing it with details in the foreground, like a doorway or some foliage.

@LILYROSE

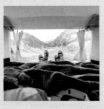

Horizontals and verticals

If you have a horizon line or something that's upright in your composition, make sure it is dead straight. Use the guidelines when cropping your image.

@MACENZO

Symmetry

Use symmetry to create graphical images – always a winner!

@SYMMETRYBREAKFAST

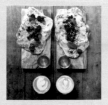

Negative space

Negative space is the 'empty' area around your subject. It helps to define the edges of your subject and can also create striking, abstract shapes in itself.

@SERJIOS

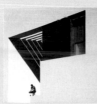

Unusual angles

Vary the viewpoints of your shots. Get on the ground or get up high – show us a new way of looking at the world!

@EDWARDKB

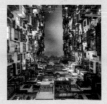

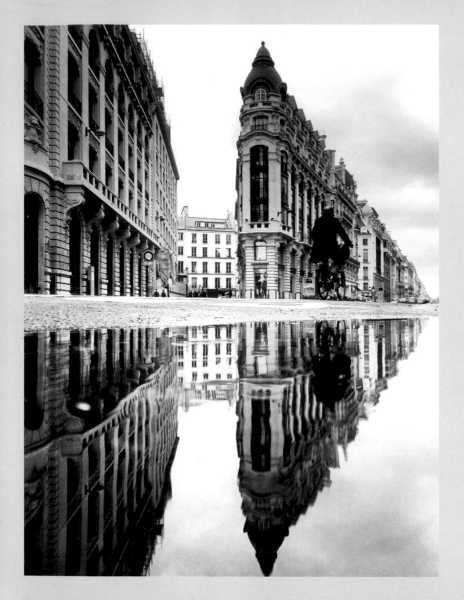

@NATHPARIS
Nathalie Geffroy
Followers: > 610k

Inspiring feeds:
@punkodelish
@scb_gordon
@serjins

Bend and stretch

When photographing streets or architecture, try taking shots from low down – often right from the ground! This offers a perspective on the familiar that your followers do not usually see. When you try different angles you suddenly notice compositional elements that were not visible to you from head height. Use reflections in puddles and the lines of streets, buildings and other features to make your images more attention-grabbing, too.

Nathalie's story

I live in Paris and work as an art director in visual communication. I discovered the photographic universe of Instagram five years ago. It introduced me to a passion for photography and an extraordinary community of adorable people! I'm a street photographer; I like capturing moments of everyday life. For me, Paris is a big playground with small districts that are all so different – a magical place of architecture, monuments and cafes.

Surround yourself with creativity

Making it on Instagram is just as much about who you follow as it is about crafting your own feed. I look to follow people who do things I'm not capable of, so I can learn from them. This source of inspiration helps you stay motivated and gives you ideas for what to shoot and where to go next. It's also very important to find inspiration beyond the app. Go to galleries, bookstores and performances. This will expose you to different forms of creativity and allow you to bring something fresh to Instagram.

Edward's story

I downloaded Instagram soon after its release and used it to share photos of food and things around my house. Things changed when I started following some really good photographers in London. The plan was never to become Instafamous. I just wanted to become a good photographer. Working with brands wasn't something that ever crossed my mind until 2014, when a fellow 'grammer asked me to get involved with a campaign for Barbour. It just snowballed from there.

@EDWARDKB
Edward Barnieh
Followers: > 155k

Inspiring feeds:
@samalive
@vdubl
@_visualmemories

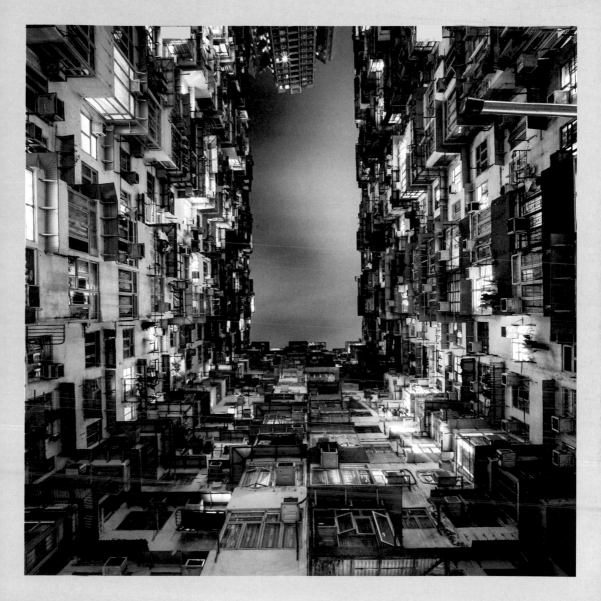

Give in to your impulses

Obey your desires. The ones that you find irresistible. The ones that are harmless. Boredom, ennui, loneliness – I think we all feel these things a lot more when we suppress and deprive ourselves of small pleasures. Why does everything need to have a purpose? Why does everything we do have to mean something? What's that thing that really gets you off? Find your own version of breadfacing and don't do it for likes or for internet fame. You don't even have to photograph it! Do it for the simple joy of the act, and do it often. You'll feel better and if people really start to connect with it then, hey, isn't that a good feeling, too?

Bread Face's story

I know this may be disappointing, but I started my Instagram because I thought it would make someone out there laugh, and that's it. I started getting a lot of attention online, which gave me anxiety at first, so I didn't give much away. In fact, only those closest to me know my identity. This has made people even more curious. People always give me advice on how to monetize and evolve, but I don't want it to become something I feel like I 'have' to do. I do want to write more and maybe make some cool jackets, but for now I'm just getting off on rolling my face in bread and taking whatever donations people send me. I just want to have fun.

@BREADFACEBLOG
Bread Face
Followers: > 85k

Inspiring feeds:
@cool3dworld
@lazymomnyc
@_monica

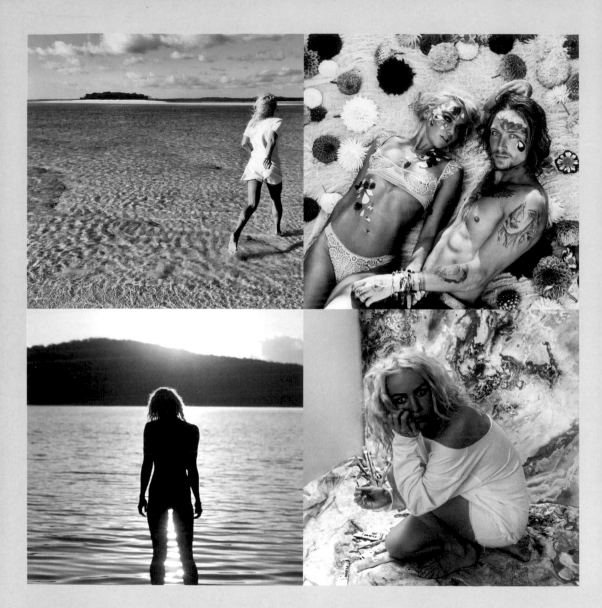

@SALLYMUSTANG
Sally Mustang
Followers: > 245k

Inspiring feeds:
@charcoalalley
@mitchgobel_resinart
@wolfcubhwolfcub

Make your pictures speak a thousand words

See social media as a huge creative outlet – a place where you can showcase your lifestyle in an imaginative way to inspire others. I try to use every aspect of my creativity when posting, from body movement, to style/fashion, artworks, colour themes and creative writing. Don't underestimate the emotive power of captions, either. I put a huge amount of effort into the writing that goes with my pictures. The visual is definitely important, but I feel that my followers really connect with me and understand the full story through my captions.

Sally's story

As an artist, yogi, influencer and regular wanderer, I'm essentially an adventurer, and passionate about being creative. Through Instagram I want to teach people how to be happy. I want to remind them to fall in love with nature. I want to leave some colour in this world and to stay multifaceted. My freedom is important. I don't want to know the answer to the question 'What will I be doing in five years' time?'

Be a straight shooter

People are instantly attracted to order in a composition. The square frame sets you up perfectly to create symmetrical shots with strong vertical and horizontal lines. When shooting facades, you're often looking up at the building. This means perspective causes lines to start converging, which is sometimes OK, but it usually causes the impact of a surface to be lost. I correct this distortion using the app SKRWT. For this shot, I was looking up at the windows, but you wouldn't know it because all the vertical lines are dead straight. It's like I put on a jetpack and shot the building from the air!

Dirk's story

I discovered Instagram at the right time in my life. I had lost my job due to illness and I found my account gave me a much-needed creative and physical outlet. I try and go 'photo-cycling' every day, which keeps my body moving and creativity flowing. Because of my background in graphic design I love to capture the 'lines' of the city. I see a strong connection between photographing architecture and graphic design. It's all about shapes, form, layout, patterns and putting things together. As a founding member of **@SEEMYCITY**, and now being an 'influencer', I have the opportunity to travel to places I wouldn't otherwise have seen. I am very thankful to Instagram for putting me back on track.

@MACENZO
Dirk Bakker
Followers: > 375k

Inspiring feeds:
@cimkedi
@cityzen63
@serjios

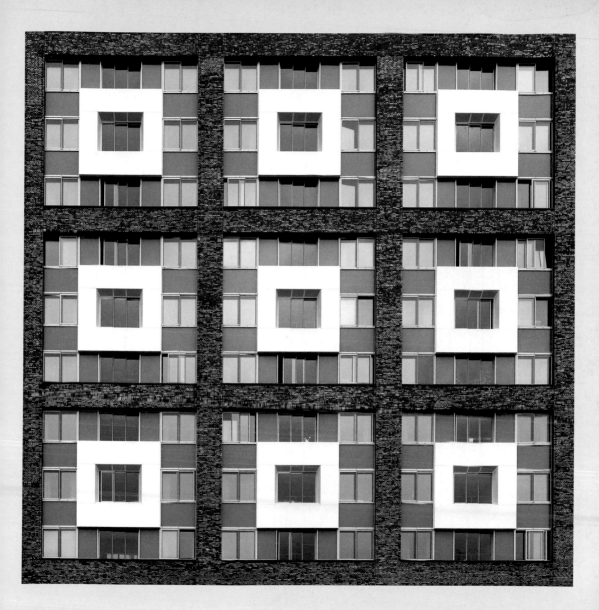

Instagram effects

Consistency is the key when it comes to refining your visual style. So here's a rundown of some essential Instagram effects using the 'Edit' button. Just remember, when it comes to editing, less is always more!

Adjust

Use this to crop your image and adjust its angle. Tapping on the grid symbol will overlay guides so you can get everything dead straight.

Brightness

This is a quick fix to make your photograph brighter or darker. It doesn't give you any creative control, so is best avoided.

Contrast

Another quick fix to make the highlights brighter and shadows darker. Again, best avoided.

Structure

This brings out more detail and texture in your photograph, but only use a small amount or your image will start to look a bit, erm, shit.

Warmth

Use the slider to make your image warmer or cooler. A small amount goes a long way.

Saturation

This increases or decreases the intensity of colours. It's fine to use this to make your image black and white – just avoid making the colours too saturated.

Colour

A way to add colour to shadows or highlights in your photograph. It can be a little unsubtle.

Fade

This gives your photo a softer feel by adding a layer of 'haze'.

Highlights

This makes the highlights brighter. A better alternative to the Contrast tool.

Shadows

This makes the shadows darker. Another better alternative to the Contrast tool.

Vignette

Adjusting the slider will add a small amount of shadow to the edge of your image, making the central area stand out.

Sharpen

Always add a tiny bit of Sharpen to finish your photograph; this will subtly enhance its look on smartphone screens.

Editing apps

While Instagram does offer editing tools, they don't compare to some third-party editing apps. There are lots to choose from, but here are the preferred choices of many of the Instagram gurus featured in this book.

VSCO

This is regarded as one of the best editing apps around. VSCO's range of tools, film-like filters and user-friendly interface mean it's easy to make your pictures pop. The editing features are very easy to use, too.

Darkroom

The closest thing to an editing program on a computer, but on your phone. Darkroom is a great choice if you want to have complete control over the look of your image.

PicTapGo

This app has a great range of soft filters and effects that are clean and subtle. It has all the basic editing features of the other apps but lets you improve the light and adjust the intensity of each filter by layering them on top of each other.

Snapseed

Snapseed is one of the oldest apps for editing smartphone images. It provides loads of tips and tricks for editing your photographs and you may need to practise before you start posting, but there are plenty of online guides to help you.

SKRWT

Loved by architectural photographers, this is one of the best perspective-editing apps there is. SKRWT helps to correct lens distortion and perspective, and also to fine-tune angles. It's easy to use, so another one to take advantage of from time to time.

Cortex Camera

This is the app to use if you're taking a photograph in darker conditions. The app takes a number of photographs at different exposures and then layers them. It's a simple app, which, unlike the others, you actually take photos with. You can also export your pictures into other apps for any additional editing.

Have bursts of enthusiasm

Capturing my daughter in a photograph can be hard work. She's a whirlwind of colour and chaos. There's no cajoling her to pose a certain way, so I set my iPhone to Burst Mode, let her tear around and keep an eye out for the moments of real magic. This is a good trick for any moving subject – the main thing is to get the shot. Like any photographer, I sometimes need to do a little tweaking, like moving any distractions from the background. For me it's all about capturing my daughter's childhood in all its glory.

Sara's story
While pregnant with my first child, I launched a photo-a-day project to have a creative outlet. Photography had always been a hobby, but I didn't have the time or energy to play with my DSLR, so iPhoneography was perfect. Once I got the hang of it, my audience quickly grew, and after a few months I had 35k followers. Three years later I left my job with the NHS and now I work as a freelance photographer, iPhoneographer and writer. It's the career I always dreamed of, but without the support of my Instagram followers and friends I would never have found the self-belief or opportunities to make it happen.

@ME_AND_ORLA
Sara Tasker
Followers: > 130k

Inspiring feeds:
@mimi_brune
@rrrroza
@searchingfortomorrow

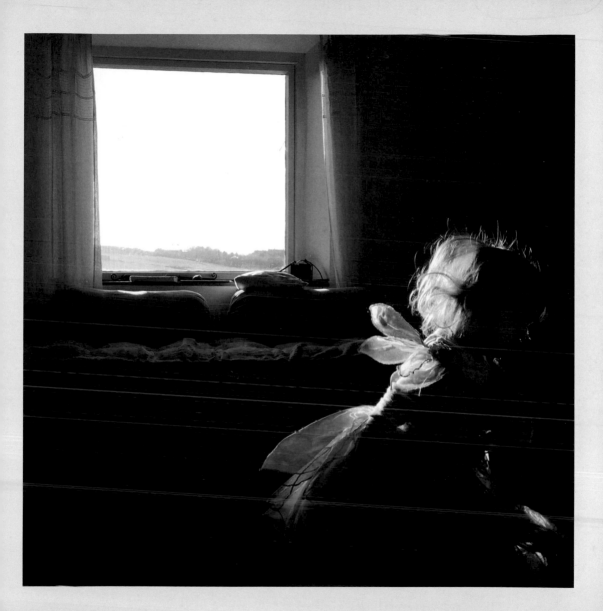

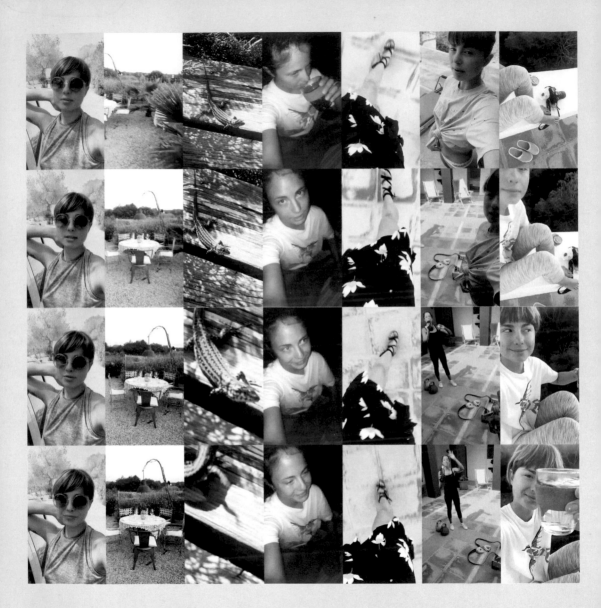

@KIKI_SUNSHINE
Ekaterina Kolenbet
Followers: > 70k

Inspiring feeds:
@chriscreature
@mimielashiry
@zarlnakay_

Tell true Stories

Instagram's Stories feature is a great way to express your raw emotions and experiences. Go with the flow and have fun. Use it to capture real moments. There are so many Instagram accounts that look too perfect and, at the end of the day, it's boring to see someone's 'perfect life' all the time. Keep it real, but don't overdo it. Remember that your Stories are an extention of your Instagram identity, so make sure that your Stories are inspirational and positive, and don't post anything that you might live to regret, especially if you want to attract brands.

Ekaterina's story

I was born and raised in Tashkent, Uzbekistan, where I went to university and received a degree in economics. I had always been interested in different forms of self-expression, such as art, fashion and photography, so I moved to Thailand to look for a fresh start and decided to go 'all in' on my creative paths. I studied fashion design for three years in Bangkok and after that moved to Italy, which is where I developed my personal style and tone of voice. I currently live in New York, and I shoot both digital and film.

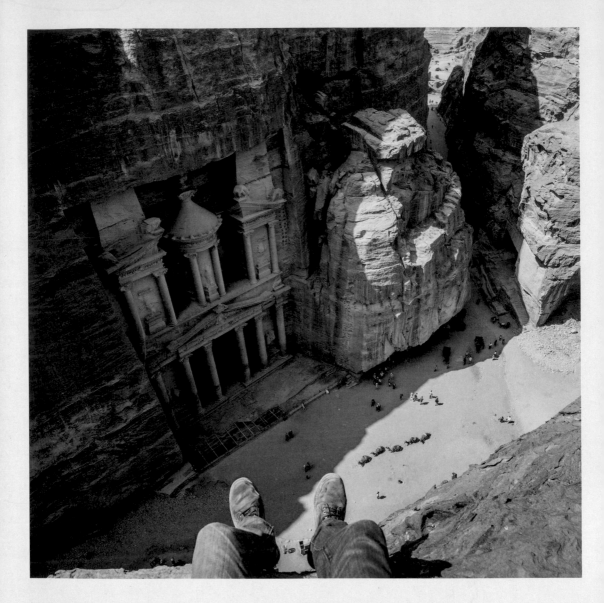

@OVUNNO
Oliver Vegas
Followers: > 410k

Inspiring feeds:
@marcogrob
@danruhin
@dave.krugman

Put yourself in the picture

Make people feel that they can transport themselves into your pictures. Literally putting part of yourself in the scene helps. It puts viewers inside your head so they are looking through your eyes. No matter how far the places you photograph are from your audience, this allows them to feel some of the same emotions that you felt when you were there.

Oliver's story

I have been on Instagram since about 2011. I started sharing my trips and my account grew little by little. People liked to see my personal point of view because it transported them somewhere else and allowed them to feel what I felt when taking the picture. My account means that I now have many more working opportunities, can visit new places and meet new people. If you ask me what it means to me, it's capture, feel and transmit.

The perfect flat lay

Styling a 'flat lay' is a foolproof way to create an image that will appeal to the masses. Set down objects near a window with lots of natural light. That's key! Also, look for nice surfaces that will complement your objects and give you lots of space. Think carefully about your composition and be aware of the space between objects and whether any of them should overlap. Keep your phone completely flat to avoid shooting at an angle. With smartphones it helps to use the grid layout.

Hal's story

When I downloaded Instagram four years ago I had no idea it would spark my passion for photography or introduce me to some of the most incredible people I have ever met. Sharing my work as a photographer and illustrator in my feed and receiving feedback encourages me to continue posting and to be myself. Whether I'm checking out **@ALICE_GAO**'s breakfast flat lays or being overcome with New York wanderlust via **@VISUALMEMORIES_**, the 'gram has inspired me on a daily basis to travel, eat and shoot.

@HAL_ELLIS_DAVIS
Hal Ellis Davis
Followers: > 55k

Inspiring feeds:
@emmajanekepley
@_janekim
@milenamallory

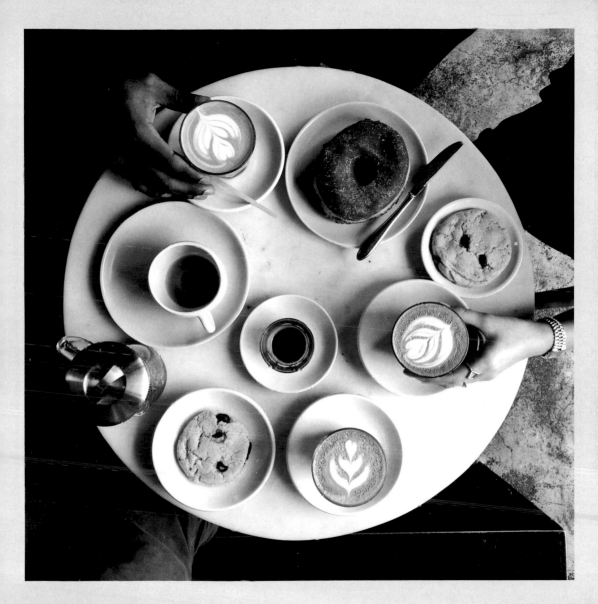

@ALADYINLONDON
Julie Falconer
Followers: > 100k

Inspiring feeds:
@candidsbyjo
@urbanpixxels
@jessonthames

Represent your city

If you're Instagramming about your own city, make sure to represent it with a broad range of subjects. Everyone loves a photo of Big Ben, but often it's my more surprising photos of little side streets or details in London that prompt the most engagement. If your audience feels like they're discovering something new about a city, whether its their own or somewhere more exotic, then they'll be more motivated to continue following and engaging with your content.

Julie's story

Originally from San Francisco, I moved to London in 2007 and started my blog, A Lady in London. I got into Instagram at the suggestion of a friend who promised I would fall in love with it, and I did. It has motivated me to get out and explore more of London and the world, and to capture images of places I love. It has been really encouraging to get immediate feedback from my followers, and amazing to be able to discover and connect with others who share my passion for London and for travel. For my blog, which has been a full-time job since 2010, I have travelled to over 100 countries and shared pictures of many of them on Instagram.

To hashtag or not to hashtag

It may not have troubled Hamlet, but for Instagram hopefuls such as yourself, that certainly is the question. On the one hand, hashtags can help you ascend to the glorious ranks; on the other, they can be your bitter downfall.

Turn off privacy

Firstly, make sure your account is not set to private. If it is, hashtags are pointless as only the people following you will see them.

Choose wisely

Hashtagging isn't about reaching the biggest audience possible, it's about reaching the most relevant audience possible. Let's say you're in Hoxton, London's hipster hotbed. Tagging your picture **#LONDON** will get you instant likes, but they are meaningless because the term 'London' is too broad. Instead, **#HOXTON**, **#OLDSTREET** or a venue like **#THEHOXTON** will attract a more like-minded engagement. Your picture will also have more longevity because you'll be in a smaller, more relevant pool of images.

Be sparing

Generally, one or two well-chosen hashtags is enough. Yes, the more hashtags you use the more likes you might get, but people will see that those likes are coming from the hashtags and not people who are genuinely interested in your content. Also, using loads of hashtags just looks a bit desperate, especially if they are really general.

Don't be predictable

Avoid copying and pasting the same batch of generic tags on all your posts. It will only mean that your images stay in the same pool rather than branching out to find a wider following. Using the same hashtags all the time also gives the impression that you're not really engaging with your own pictures, so why should anyone else?

Always be looking

The popularity of hashtags rises and falls. It's good to use emerging hashtags as this makes you look like you're an early adopter rather than a follower. If your account has a very specific theme, keep an eye on all the hashtags that are relevant and get a feel for when to use them.

Hedge your bets

Consider using a range of tags on a post. Perhaps pick three relevant ones consisting of one which is really popular, another that is semi popular and then a third that is quite niche. This means you'll cover all bases and your image will benefit from an initial burst of attention, but will then live a little longer.

Make them less visible

Captions are engaging, especially if you are describing an experience or a story behind your picture. Hashtags tend to be functional and a bit ugly. So rather than include them in your caption, add them in a comment. This will then 'disappear' when your post receives more comments.

Get creative

The most obvious thing to do is to hashtag the subject of your image, like **#SEA**. But you can also use more emotive hashtags which relate to the mood of your image. This is one of the reasons why **#FOLLOWME** really took off. It reflects an attitude or feeling, rather than something literal.

Create your own

If you're pursuing a project or a sub-theme within your feed, create your own hashtag so that your followers can quickly filter down to that content; **@SEJKKO** (see p.108) does this with **#SEJKKO_LONELYHOUSE.** If your hashtag is also quite emotive, you'll find that other people pick it up and start using it in their posts, too. In which case, it's a good idea to include the hashtag in your profile bio, so you are recognized as the creator.

Weekend hashtag project

Don't forget that every weekend Instagram run their own hashtag project. This is a great way to engage with a wider audience – and you might even get spotted by Instagram HQ and become a suggested user!

Shoot full-frontal fashion

A good full-length portrait isn't all about you. Think about
the background and how the colours and patterns relate to the
clothes. Clean, coloured backgrounds are good for making
clothes stand out, but brickwork or plants can help highlight
fabrics and tones. I avoid harsh sunlight as it's too contrasty and
unflattering on the skin. Look for shaded walls instead where the
light is softer. With your pose, inject a bit of attitude by staring
right back into the camera or a candid feel by gazing off frame.
Finally, always be on the lookout out for interesting backgrounds
that you can return to later.

Gabi's story

I started my blog, gabifresh.com, in 2008, as I had an interest
in fashion journalism. Because I didn't have any experience,
I decided blogging would be a great platform to show off my
writing skills and love of fashion. My Instagram account
followed in 2011 and now both platforms have transformed into
my personal style blog. I think my popularity comes from the
fact that my fashion advice basically consists of 'ignore fashion
rules!' and I fill a void for the under-represented younger, trendier
women who are size 14 and up.

@GABIFRESH
Gabi Gregg
Followers: > 400k

Inspiring feeds:
@theashleygraham
@nadiaaboulhosn
@misslionhunter

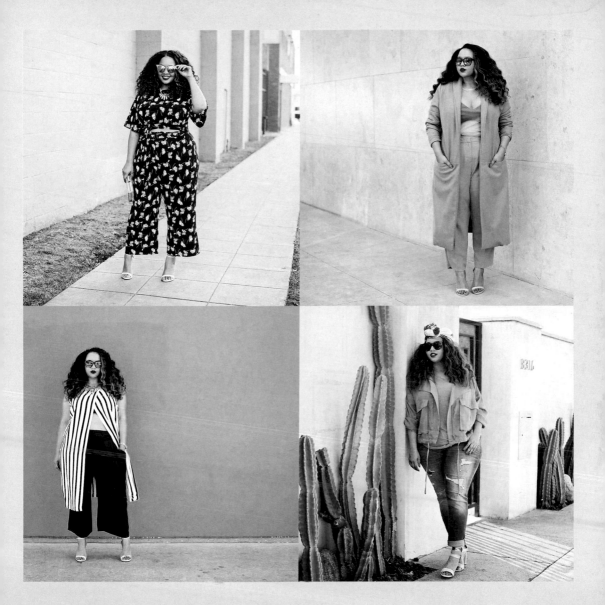

Create breathing space

Even though Instagram now allows you to post in any format, I still find borders distinctive and powerful. They give more space to each image, and thereby more respect. That said, if you're using borders it's easy for your feed to feel a little messy or irregular. Try out the app Whitagram. Create order by sticking to standard proportions or aspect ratios. I also post landscape- and portrait-format pictures alternately, as I like the way it makes my feed feel clean and gives it more visual impact.

@NICOLE_FRANZEN
Nicole Franzen
Followers: > 195k

Inspiring feeds:
@jaredchambers
@salvalopez
@schonnemann

Nicole's story

I started my Instagram account back when it first launched. Taking photos with an iPhone was just becoming a thing and I was in love with the idea of having an accessible way to post and share pictures. I use Instagram to follow like-minded artists and brands. It started slow and steady, but getting on the recommended users list and being featured regularly helped get my follower numbers up. I have since worked with a handful of brands and tourism boards.

@KATIA_MI
Ekaterina Mishchenkova
Followers: > 545k

Inspiring feeds:
@anasbarros
@audiosoup
@civilking

Speak your followers' language. Literally.

If English is not your first language, then it's important to think about what language you use on Instagram. The two main languages that my followers can understand are English and Russian. That's why I use both in my captions. If people can't understand what you are saying then it's hard to count on their love – and hard to get new followers! This is especially important if you want to appeal to an international following and global brands.

Ekaterina's story

I work as an art director and social media strategist. I started my first Instagram account, **@KATIA_MI**, in 2012, which is dedicated to art and concepts. After a while I opened another account, **@KATIA_MI_**, which is focused on travel and lifestyle. For me, being popular on Instagram is less about fame and more about making new friends all over the world. It's about breaking down borders and connecting with people who are passionate about visual storytelling.

Collaborate!

Creating and managing a successful Instagram account can be hard work. You don't have to do it on your own, though. Try starting an account with some like-minded friends. It's way more fun! The three of us share the same enthusiasm for our account but there are always times when one of us needs a moment off. In that case, the other two take over the 'work'. Create a WhatsApp group to communicate with each other regularly. We don't worry too much about who is posting next. We just check the time of the last post to see whether it's time for another. It flows very naturally.

Edith, Josha and Pien's story

Our account started in June 2014 in a bar in Amsterdam. There was a nice floor and we discovered that all three of us had this thing with floors. We talked about sharing our own floor pictures on our new account but decided to make it a social platform for people from all over the world. Our following grew insanely quickly, and recently we have been tagged and named by huge bloggers, magazines and celebrities like Reese Witherspoon. There have been many high points, but our biggest was hitting 500k followers 15 months after we started.

@IHAVETHISTHING WITHFLOORS
Edith, Josha and Pien
Followers: > 720k

Inspiring feeds:
@ad_magazine
@jean_jullien
@mariestellamaris_official

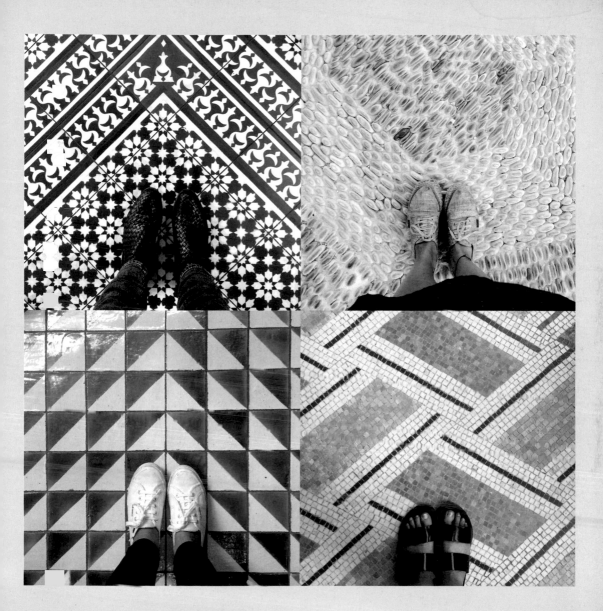

@KITKAT_CH
Martina Bisaz
Followers: > 205k

Inspiring feeds:
@brahmino
@daniel_ernst
@ravivora

Where are you?

Geotags are one of the best ways for a post to maintain engagement over a long period of time. When I'm travelling I use them to create a kind of diary so I remember the names of the places I've visited. Another reason to use geotags is because it increases the ways your photos can be found when people search by location. Even if you're in your own neighbourhood, using geotags will help you build up a local following. Apart from that, geotags document a place over time, and you can be part of it.

Martina's story

I was born and raised in the beautiful Swiss Alps. Nature and mountains have always been an important part of my life, but my job in an archaeology department has meant that I've lived in Zurich for ten years. I love classic cars, too, which is a bit of a Bisaz family thing, and I'll never miss a chance to go back to the mountains on free weekends – in one of my beautiful old vehicles, whenever possible. Since discovering Instagram, photography has become my third passion, alongside cars and travel, and it allows me to keep a record of the other two.

Fast-track your following: the facts

So, yes, it's true that you need to learn to take pretty pictures and be nice to your fellow 'grammers. But that alone won't help you rise to the top. Here are some cold, hard facts that will.

12.6%

more engagement when your post includes at least one hashtag.

36%

more engagement with photos compared to videos.

38%

more likes when your picture includes a person or face.

56%

more engagement
when you include
another user's handle
in your post.

79%

more engagement
when you geotag
your post.

Photograph a feeling

Capturing a specific mood or feeling, and keeping that consistent from picture to picture, can be just as powerful as having a specific theme, like landscapes or food. People will follow you because of how your feed makes them feel. It might offer them an escape at the end of a hard day or put them in the right frame of mind in the morning. I photograph flowers, food, landscapes, still lifes and accessories. The subjects are very different, but the lighting, exposure, focus and composition helps hold everything together. I also use a range of cameras, not just my phone. I even shoot film sometimes.

Naomi's story

I work as a pharmacist but I love photography. I started my account in October 2010. I wanted to capture my love of natural light, as well as beautiful encounters with nature. I suppose my account feels very Japanese, but only 10 per cent of my followers are in Japan. That's what I love about Instagram. It connects me with people from different cultures around the world.

@NAO1223
Naomi Okunaka
Followers: > 280k

Inspiring feeds:
@wagnus
@utopiano

@NALA_CAT
Varisiri Methachittiphan
(Nala's mummy)
Followers: > 3m

Inspiring feeds:
@catsofinstagram
@cats_of_instagram
@white_coffee_cat_

Paws for thought

One of the things that's pretty popular on my page are the props that my mum puts on me to take the photos. Even though my mum tells me all the time that it's normal for cats to wear shark hats, I have a hard time believing her. It doesn't bother me any longer because we've been doing this for a while now and it makes for a good picture. But I want to make sure that anyone who plans to use props or put anything on their pet checks that it's comfortable for them. Some of my friends tell me that even though they agree that my hats are cute, they themselves don't like putting things on their heads. They prefer a good bow-tie, or for the Xmas tree to be kept in the background.

Nala's story

Miaow everyone! My name is Nala and I am a female Siamese-tabby mix. I am six years old, although I'm not really sure when my actual birthday is. My mummy adopted me from the animal shelter when I was around five months old in November 2010, so I'm guessing I was born in June. I'm not sure why I was left at the shelter, but they said I came from a house with too many cats. I hope my friends are all OK and are happy with their new families, like me. People have commented that they like my Instagram account because I brighten up their day when they are feeling down. I suppose that's why I have so many followers.

Wait for the light to be right

Photography should be about storytelling and capturing moments. That's why natural light and shooting at particular times of the day is so important. Use light to dictate the mood of your image. I have always been drawn to golden light in the morning or early evening. It has a softer feel and the warm colours make everything glow. Sunlight is one of those things you have no control over, though, so be organized. Plan your shoots in advance and then wait until the light is just right. That will make all the difference.

Emilie's story

I am a photographer, storyteller and wanderer based on the east coast of Australia. My photography work is built upon natural light and nostalgia, and I aim to gather beautiful moments and tell stories through the images I create. Instagram has had a hugely positive impact on both my business and my personal life. It has opened up a whole new range of opportunities to collaborate and develop my own creative community across the globe.

@HELLOEMILIE
Emilie Ristevski
Followers: > 720k

Inspiring feeds:
@alexstrohl
@lilyrose
@sejkko

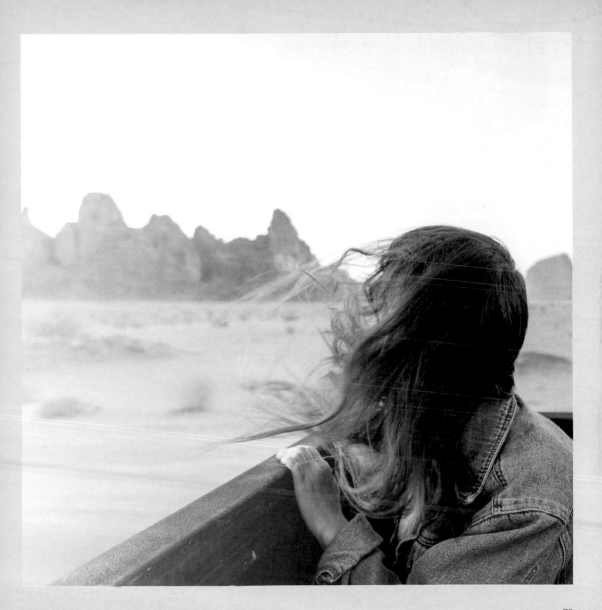

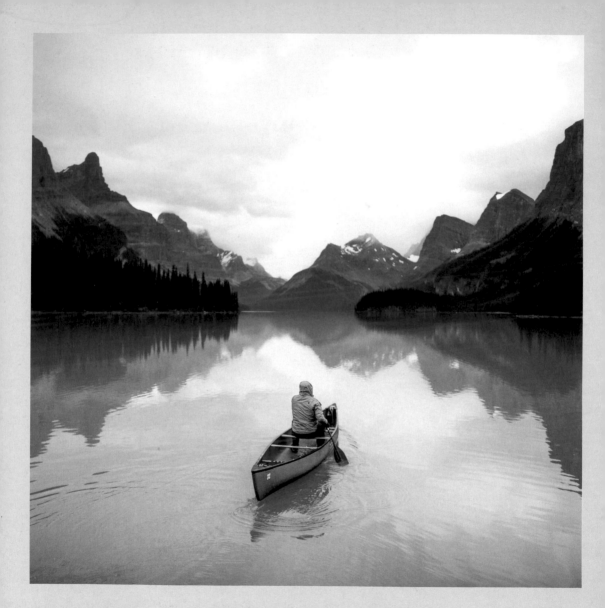

@DANIEL_ERNST
Daniel Ernst
Followers: > 245k

Inspiring feeds:
@everchanginghorizon
@hannes_becker
@samuelelkins

Be a people person

When scrolling through my feed you will notice that most of my photos contain a human element. I try to put a person in most of my photos to give the landscapes I shoot a sense of scale as well as a way for viewers to imagine themselves in the picture. This allows the inclusion of inconspicuous advertisements for gear and clothes brands. When you travel alone, you can use yourself as a model, but a tripod and remote are absolutely necessary. This means you'll also end up with a nice selfie!

Daniel's story

I'm a Germany-based adventure and travel photographer constantly in search of the perfect moment. My feed is a reflection of my passions: an outdoor lifestyle and the spirit of adventure. I want to inspire people to escape their routines, to go outdoors and explore and experience nature. I originally started using Instagram as a tool to connect with people rather than to promote myself. I still use it in the same way, but now it also gives me the opportunity to connect with brands.

Practise creative accounting

If you find yourself wanting to explore two very different themes on Instagram, start a second account. I did this so that my main account remained a distinctive gallery of images. It's nice to have a second Instagram account where you don't care too much about when and what you post, which can be a pressure when you've built up a successful main account! Go to Linked Accounts in your settings to add another account.

Kim's story

I'm from Switzerland originally, but currently studying for a photography degree in London and travelling the world. Instagram completely changed my life from the day I joined in 2011. It opened my eyes to the beauty surrounding me every day. It allowed me to share a part of my personality that I never thought I had, and to become more creative and confident. Since I've moved abroad, my Instagram journey has become even more special, thanks to the connections and friends I've made through the app.

@KIM.OU
Kim Leuenberger
Followers: > 115k

Inspiring feeds:
@ali.horne
@josephowen
@whatalexloves

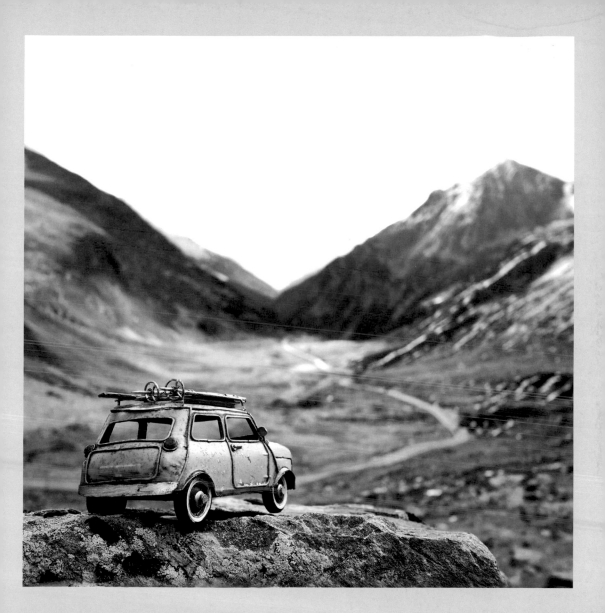

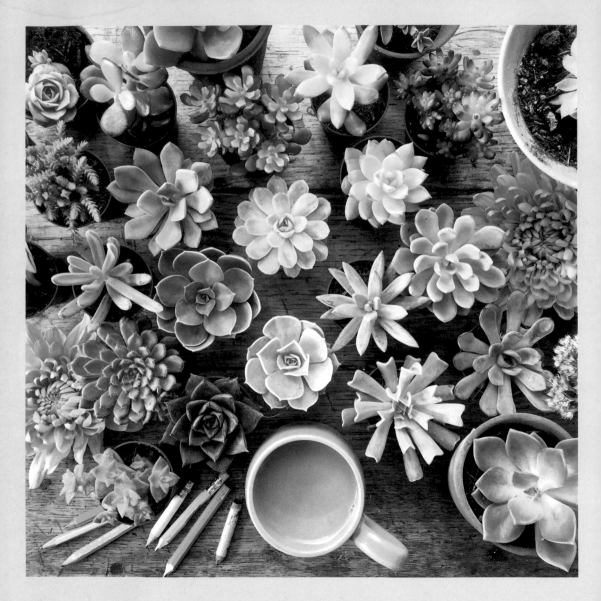

@5FTINF
Philippa Stanton
Followers: > 475k

Inspiring feeds:
@kbasta
@mctoro_o
@ncour

Do it your way

When your account gets to a certain point, it's inevitably going to attract the attention of brands. This is great, as it means a potential income from your creativity, but I think you also have to be absolutely true to your artistic self. Of course, it's hard to turn down opportunities, but sometimes it's really not worth doing something if it doesn't feel right or takes you in the wrong direction. I regard working with brands as being like producing commissioned artwork: if they want to show their product on your feed then they have to let you do your own creative thing and not interfere with that process.

Philippa's story

I initially trained as an actor at RADA and managed to combine painting and acting for over ten years. I started my Instagram account out of curiosity in February 2011 and the idea of being Instagram famous was not even on the horizon. I never decided on my theme – it just grew from sitting at my table procrastinating. Instagram is like my creative notebook, it is always with me. I only decided recently to be represented by a digital agent as I prefer to create rather than negotiate, and as an actor I have been used to that type of relationship for years.

How to become a suggested user

Many of our contributors were fast-tracked to fame because the Instagram gods elevated them to the sacred status of 'suggested user'. This means you're promoted and followed by **@INSTAGRAM** for two weeks. Instagram HQ play their cards pretty close to their chest with this one, but they have shared a few insights. So based on what they do say, here's how to find yourself at the pointy end of Instagram's fickle finger of fate:

'Bring a unique perspective to Instagram by sharing inspiring, original photos and videos'

In other words, find your niche and stick to it. Then post really good content. Check out our compositional tips on page 36. Don't get all weird with different kinds of filters or let a drunk toilet selfie infiltrate your beautifully curated feed of cocoa-dusted cappuccinos.

'Actively engage in and help cultivate the larger Instagram community'

Basically, reply genuinely to comments and post genuine comments on other feeds. Be passionate about other users' content. Tag them in posts and try to help them grow their following too. Hell, why not get off your booty and organize an InstaMeet? Check out what **@PHILGONZALEZ** has to say on page 116.

'Inspire creativity in fellow Instagrammers by doing things like participating in @instagram's Weekend Hashtag Project'

A bit of flattery goes a long way at Instagram HQ. Promote what they are doing by getting involved with their Weekend Hashtag Projects and encourage your followers to enter, too. Keep checking into the Instagram blog and share things of interest on your feed. Also, create your own hashtag and encourage your followers to use that, like **@IHAVETHISTHINGWITHFLOORS** (see p.68) did with **#IHAVETHISTHINGWITHFLOORS**.

'Keep in mind, we only highlight members of the community that follow our Community Guidelines'

This is common sense really. Basically, don't post other people's images without asking permission and crediting them, don't spam other users, don't post anything too angsty, be nice and don't be controversial. And remember, Instagram HQ is pretty prudish, so if you're going to get naked, keep it arty like **@SALLYMUSTANG** (see p.44).

Other things that Instagram doesn't say:

If you look at the majority of suggested users, it's clear that Instagram has a preferred style. Of course, there are always exceptions to the rules, and although Instagram doesn't explicitly say these things, here are some more pointers to keep in mind.

Don't over-cook your pictures

Instagram HQ likes it natural. Although they give you filters to play with, they don't like it when you push them to the extreme. Take a few minutes out between editing your picture and posting it. When you come back, trust your instant reaction. If you think your edits are too much, knock them back a bit.

Keep it pure

Stylistically, Instagram HQ seems to favour natural light, symmetry, clean compositions and brighter, fresher exposures. Negative space is always a winner.

Post consistently but not constantly

Don't go AWOL for too long and definitely don't post multiple images at a time. This not only frustrates your followers, but it also presents you in a bad light in the eyes of Instagram.

Don't look desperate

Using excessive hashtags makes you look like a desperado. Instead, show Instagram that you're thinking about your content by using considered hashtags (not generic ones like #VSCO or #FOLLOWME).

Follow the zeitgeist

Fashionable folk rocking that artisanal, 'just doing my thing' look always goes down a treat. Tap into what's on trend but also try to find your own style.

Be careful what you wish for

When you do become a suggested user you'll feel great because for a few days your follower count will sky rocket. You'll want to go out and party. You might even start to get delusions of grandeur and unfollow your mum because she's 'just not on brand'. But soon enough your follower count will start to fall. And fall fast. This is normal, so don't let it get you down. Just make sure you keep up the engagement with more great content and put time aside to interact with your new followers.

And finally

You'll know when you've been picked as a suggested user because Instagram HQ will DM you. You can, of course, decline, but if you were going to do that, then you wouldn't be reading this book, right?

Be active

The key to getting lots of new followers is to be really active on the app. Post a lot, making sure to select only high-quality photos. If you have the right content, you can even post up to four or five times a day. Just make sure you spread it out so you don't saturate your followers' feed. The more you post, the more your followers will give you likes, meaning that their own followers will discover your content and feed, which can end up with a follow from them. Don't forget to like and comment on people's photos you like as well!

Johan's story

I'm a Belgian self-taught travel photographer with a passion for wilderness and the outdoors. In late 2013 I left Europe to spend two years exploring Australia and New Zealand. I had no aims other than to explore with my backpack, but when **@NATGEOTRAVEL** and **@AUSTRALIA** started to repost my photos, things got serious and people started to follow me. My photos have since featured in the likes of *National Geographic Traveler*, the *Daily Mail*, BuzzFeed, Mashable, *Outside Magazine* and *Business Insider*.

@LEBACKPACKER
Johan Lolos
Followers: > 330k

Inspiring feeds:
@alexstrohl
@fursty
@markclinton

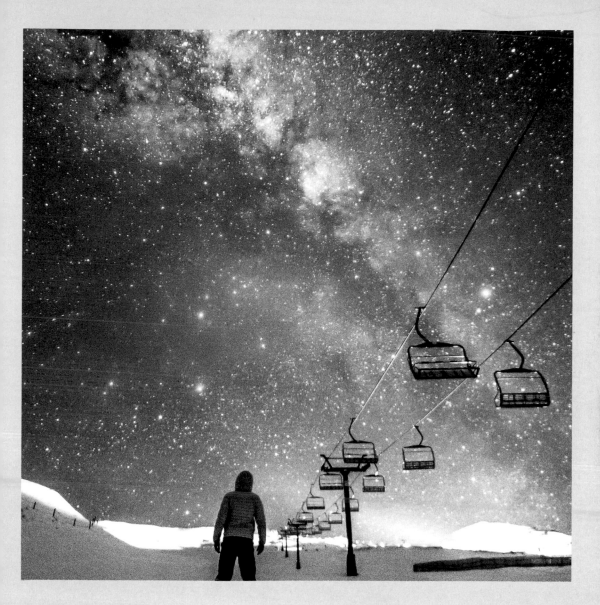

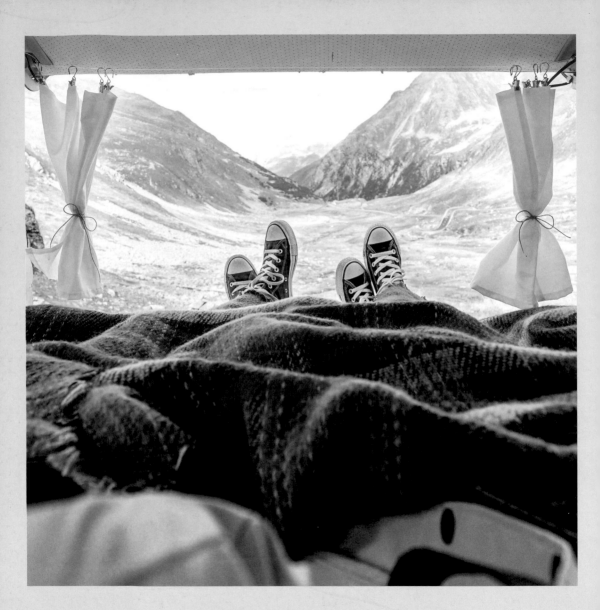

@LILYROSE
Lily Rose
Followers: > 225k

Inspiring feeds:
@benjaminheath
@elizabethgilmore
@helloemilie

Turn followers into friends

Don't be afraid to meet people in real life through Instagram. Go to organized InstaMeets to connect with people who are passionate about the same things as you. It's an incredible community! Most of my closest friends are people I've met through Instagram. That's why I love the app so much. It goes beyond the social media aspect and brings people together in real life. Meeting like-minded Instagrammers will inspire you to work harder and believe in your dreams.

Lily's story

A few years ago I quit my job to travel the world. On returning to France after the most amazing time away I became so depressed. Then a fantastic new app came along and kept my mind busy. I discovered a passion for photography and fell in love with capturing and sharing images. That was five years ago. It's insane that I used to be a dispensing optician and today I'm a travel and lifestyle photographer. It's still hard for me to believe!

Create a home studio

Most of my photographs are done indoors at home. You just need a white wall for the background and plenty of natural light. It's an easy set-up that gives pictures a professional look. I'm lucky to have big windows at home. Depending on which direction your windows face, you'll find that the light is better at different times of day. In my case, it's great in the morning until early afternoon and that helps to keep the look of my pictures consistent. Finally, place a big white board opposite the windows facing your set-up to reduce or soften shadows.

Peechaya's story

I started using Instagram in 2012 out of curiosity. I wasn't very active at first and didn't have a plan for the type of photography I am now doing, but my background in graphic design may have had some influence on my style. Over time I came to enjoy taking photos of everyday objects. It feels great when my work entertains people and is part of their daily life in some way. I have two young children and they are also my great inspiration. Instagram has now become part of my family routine and a major topic of conversation.

@PCHYBURRS
Peechaya Burroughs
Followers: > 95k

@CUCINADIGITALE
Nicolee Drake
Followers: > 555k

Inspiring feeds:
@palomaparrot
@piluro
@samhorine

Time it right

I think it's important to post within the rhythm of your normal daily routine. I don't have a strict posting schedule, but I do try to post when I know that the bulk of my community is online and engaged. A good way to think about it is in terms of where in the world the majority of your audience is located, and what their daily routines might look like. Most people check their feeds when they get up and when they go to bed. So, for me, posting in the evening in Europe also means saying good morning to my community back home in the States.

Nicolee's story

I'm a Californian girl with an eye for storytelling. I downloaded Instagram in 2011 and used it as a way to explore and learn about Rome, where I've been based since 2009. I thought it would be a great way to share my experiences with friends and family back home in the US, but then it turned into this amazing creative space that I reach out to every day. I am inspired daily by Rome's cinematic quality, everyday life and the nostalgia of Americana. I have an MFA in new media and enjoy well-loved bicycles, worn-in Chuck Taylors and descriptive hand gestures.

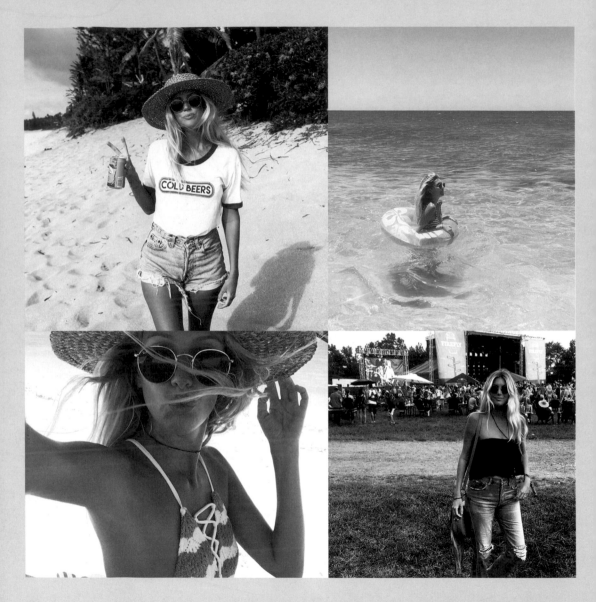

@THE_SALTY_BLONDE
Halley Elefante
Followers: > 315k

Inspiring Feeds:
@flynnskye
@h0tgirlseatingpizza
@folkrebellion

Be yourself

I believe that being approachable and genuine will always work in your favour. If you take it too seriously and are faking it, it will become a job. Also, be original. Instagram is so saturated as it is, so you need to stand out and set yourself apart from the rest. I'm a snarky, sarcastic chick who loves clothes and beer and that's precisely what you see on my page. Being yourself makes life so much easier! And remember, nobody is perfect (perfect is boring), so there is no need to edit your page like that. We aren't here to make others feel bad about themselves, it's all about inspiring them.

Halley's story

I created my account in March of 2014 after my fiancé and I moved to Oahu from NYC. I was still bartending at the time, which was my gig for pretty much a decade before this crazy venture. I was so broke I just styled old pieces from my closet, mixing my NY style with my new beachy vibe and kept my captions light and funny. Before I knew it, I was gaining traction and realized how much I really loved it. I was able to leave my job exactly one year later. Since then, I have had such amazing opportunities and travelled to places I never thought I would see. I truly still have to pinch myself.

Make a difference

On Instagram you have to be true to yourself and what you enjoy. Other people will appreciate that. It's also OK to be different. For example, I wanted to use humour to comment on our capitalist hopes and fears while at the same time raise awareness of cat inequality. **@CASHCATS** may look like a silly account, but its legacy will be all the money it has raised for cat charities. What do you care about, and how can you use Instagram to make a difference?

Will's story

Cashcats is an online VIP room for the world's high-net-worth felines. I launched Cashcats.biz in January 2011 and have received over 5,000 submissions from around the world. This global aspect is one of the most interesting aspects of the project. Through various art shows and merchandise sales, fans have helped raise more than $11,500 for animal charities across the US.

@CASHCATS
Will Zweigart
Followers: > 145k

Inspiring feeds:
@fugazi_cat
@meowquarterly
@princesscheeto

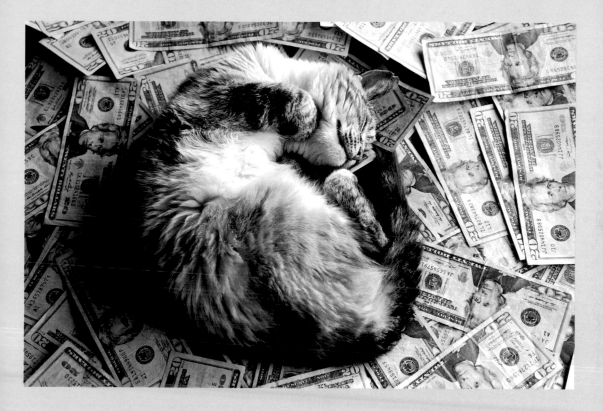

Money, money, money

So let's cut to the chase. How do you create an account that will catch the eye of brands, exactly what deals are done and how much money can you make? We asked Nia Pejsak, a marketing manager for a leading fashion house, to lift the lid on the most secretive side of Instagram.

How can aspiring Instagrammers increase their chances of being approached by brands?

Brands look for someone who will resonate with their target market. In fashion, for example, that person should be an authority on the brand's particular style and lifestyle values. Make sure your followers feel like they are getting a glimpse into your world as brands really value that personal connection. I would recommend creating a list of your target brands and, as your account grows, keep in mind whether the lifestyle you're showcasing mimics that of the brand.

Don't forget to consider brands outside your specific field, too. For example, a distinctive food account will attract the attention of fashion and travel brands because it's an effective method for getting their product to a new audience and reinforcing their wider lifestyle values.

How many followers does someone need before they become an 'influencer'?

People tend to fixate on follower count, but engagement is perhaps more important from a brand's point of view. Engagement refers to how followers interact with a post. Are they just scrolling past it in their feeds or do they choose to 'like' the post or comment on it? If they do comment, what are they saying? For example, there's a swimsuit model with over a million followers. If you look at the comments that her post attracts, a lot are from ogling men more interested in what's under the swimsuit than the garment itself! This highlights what a large part of her million-plus following actually consists of, and a swimsuit brand would be better off partnering with another, smaller account that is followed by girls actually interested in the fashion. So, in terms of being an influencer, in this case the smaller account would score higher.

What factors determine how much an Instagrammer should charge?

A simple calculation, such as the percentage of likes/comments vs following, is an effective way of analysing your average post engagement against similar accounts. Brands will look at this too, as it exposes whether an Instagrammer with a high following actually carries influence or not. But then one has to take into account the number of posts that you'd be expected to make about the brand, whether that's just on Instagram

or across other social channels; whether they are exclusive posts or shared with another brand; and whether you are expected to come up with original content or simply post existing images. Many of the top influencers on Instagram started as bloggers, so they are able to offer packages that include a post on their websites. Another factor is the creativity that you'll bring to the post. Is the brand getting content that can be reposted on their channels, or even a whole photoshoot that they might use to sell product on their website? This can be sold in as added value.

So what are the going rates?

Once you've built up a decent number of followers you can begin charging. But don't even think about buying followers, as this will always result in low engagement and brands will see right through it. So basically, Instagrammers with a follower count in the hundreds of thousands with good engagement will typically charge around $500 to $1,000 USD per post. A takeover could earn anything from $2,000 to $10,000, depending on the length of time and number of posts. Being signed for a whole campaign such as a package that includes ads, in-store imagery and a set number of posts for the period of that campaign could earn around $20,000 to $30,000. There are whole other deals too, which include commission on product sales. These are generally reserved for brand ambassadors, but that could be up to ten per cent on total sales.

Would you recommend working with an agent?

For sure. First and foremost, they'll have established relationships with brands which you'll get access to. They can help you strike better deals and also enable you to piggyback on the bigger influencers on their books to build up your profile faster. This can include 'spend over' deals, where brands are offered a package that includes posts by the top influencers and some 'free' bonus exposure via posts by the smaller accounts.

Any other advice for aspiring Instagrammers?

Be personable. Instagram is a crowded space, so stand out as genuine. Captions should be snappy and grab people's attention. What's your personality or tone of voice within the caption: serious, friendly, funny or cheeky? Encourage engagement! Ask questions, interact with your audience through comments and give reciprocal likes/comments to your peers. See Instagram as a community, not a competition. Extend your reach by posting something that'll resonate with your audience and make them tag their friends. Partner with other influencers to double your exposure as you've both got a different audience to gain. Be scientific by keeping an eye on your stats to see which of your posts get the best engagement. Brands will expect you to have a document outlining this and the other other key selling points of your account.

Nia has worked in fashion marketing management for brands such as Mulberry, Lacoste, Minkpink and online retailer Net-a-Porter. She is currently studying for a Masters at the London College of Fashion.
@NIAPEJSAK

Add the human touch

Never underestimate the power of a story in a photograph. I mostly photograph buildings, but I think that my images appeal to a wide audience because I also like to capture moments. This could be a person hurrying through a space, a reflection of my hand in a puddle, a bird in flight or the changing light. These elements stir the viewer's imagination more than a photo that simply shows them what a place looks like. Including them helps people relate to a space because it immediately feels more human.

@NUNOASSIS
Nuno Assis
Followers: > 240k

Inspiring feeds:
@chrisconnolly
@konaction
@mihailonaca

Nuno's story

I started sharing photos on Instagram in March 2012 as an escape from my day job as an architect. At the time I was missing the creative side of architecture, so photography became an extension of my work and a way to record my daily thoughts and my environment. Architecture plays a huge role in the way we perceive and relate to cities and places. It frames and uncovers a whole spectrum of possibilities and it was natural that it became the theme of my account. It is also interesting how interconnected architecture and photography are nowadays. One almost doesn't exist without the other. Everywhere I look I see a photo opportunity and a moment to remember. This is my life now.

@THEFELLA
Conor MacNeill
Followers: > 195k

Inspiring feeds:
@ovunno
@twheat
@whatinasees

Take a different point of view

The best landscape shots are the ones that really inspire a sense of wanderlust in the viewer. As with any great landscape photograph, you need to have a good sense of composition and colour. This goes without saying. In addition, try showing people something that they might not have seen before. You might be shooting a scene that people have seen a thousand times before, especially on Instagram, so hunt out the unusual viewpoints and focal points to make sure your photograph succeeds in impressing your audience!

Conor's story

I am a fine art, travel and landscape photographer based in the UK, but aiming to visit every country in the world. I took up photography as a hobby to avoid getting bored when travelling on my own, and created my Instagram account in 2010, a couple of months after it launched. It was perfect timing because it was around the same time that I really started getting into photography and travel. Fast-forward a few years and I no longer have my day job as a web developer. Now I take photographs and Instagram for a living – mainly for the travel and tourism industry, as you might expect.

Mastering the still life

@C_COLLI
Cristina Colli
Followers: > 90k

Inspiring feeds:
@caroline_south
@5ftinf
@toile_blanche

Before you start your still life, think about the story you want to tell. A still life, whether it is flowers in a vase or food on a restaurant table, is visual storytelling. You are in control of all the elements – subject, lighting, textures, shapes, colours – and each of these elements evokes a mood, so arrange things accordingly. Position your objects carefully and try to create a flow that directs the eye to those that you want to highlight. Use negative space (see page 37) to make things stand out, and keep in mind that you don't always have to show the whole object – cropping part of it leaves more to the imagination. All the fundamental rules of composition still apply and you can use accents of colour to draw the eye and create rhythm, like I have done in this image.

Cristina's story

At first I used my account to post random photos without a theme. After a while I decided to post only floral images as a way of saying good morning and wishing a lovely day to my followers. That's when Instagram became my happy place and I started to connect with a wonderful community of talented, supportive people. Now Instagram has become a big part of my day-to-day life. Posting regularly keeps me motivated, and pushes me to stretch my creative muscles and grow as an artist. Most of all, I'm grateful to this wonderful app because it helped me connect with my tribe of creatives and flower lovers.

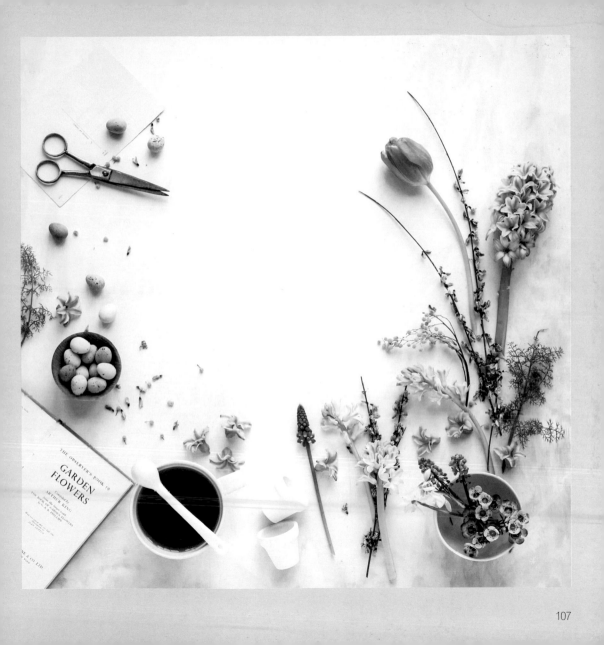

107

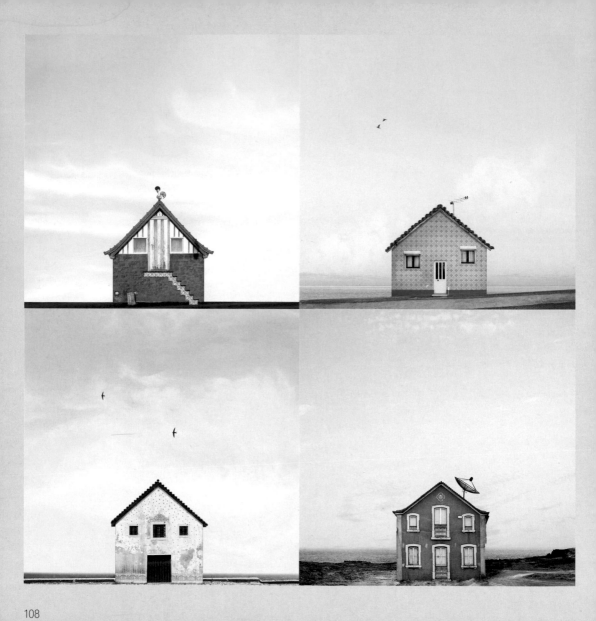

@SEJKKO
Manuel Pita
Followers: > 240k

Inspiring feeds:
@amandademme
@brahmino
@kbasta

Find your smile

The most important thing is to express your character on Instagram by taking pictures that make you smile. I've found that I smile the most when I produce uncluttered, fairly minimal images. I like to find one single element, like a building, tree or person, to take centre stage. I never ignore the background or environment, and use that to support my subject. This style now feels very natural for me and gives me focus. What makes you smile?

Manuel's story

At school I had to make a choice between science and art and I chose science. Many years later Instagram became a way for the artist in me to find a channel and flow again. The last four years have been incredible for me as I now see how both sides of my character connect. Sometimes they are confrontational, sometimes they cooperate completely. At the moment I feel there is an intense evolution happening in my artistic side, and I am loving it.

Listen to yourself

Connect with something that you feel very close to – something personal and unique but effortless because it is somehow part of you. It could be a hobby, something in your neighbourhood or something that you really like. Of course, it is important to be creative and to create your own world, but even more important is to explore yourself and communicate who you are. We are all individuals. Draw on that to connect with others.

Isabel's story

When I joined Instagram in 2011 my goal was never to be a famous Instagrammer because that concept did not exist then. For me Instagram was, and still is, a way of being creative without boundaries. I was honoured to be featured in *Vogue Italia*'s 'A Glimpse at PhotoVogue' exhibition in 2012. Then, in 2014, The Cut included me on their '50 Fashion Social Media Voices to Follow'. After that, the agent Katy Barker, who built the careers of Terry Richardson and Craig McDean, began representing me, and in 2015 I was featured in *Yo Dona* magazine as one of the 500 most relevant Spanish women of the year. I still think all this is a dream...

@ISABELITAVIRTUAL
Isabel Martínez Tudela
Followers: > 720k

Inspiring feeds:
@hombre_normal
@oneeyegirl
@unskilledworker

Do you need representation?

Apart from just sounding cool, having an agent can quickly elevate you to Instagram stardom. But what does an agent do exactly? How do you get one? And why would they be interested in the likes of you? We asked straight-talking blogger agent Nadine Andrews for some no-nonsense answers.

What's the advantage of having an agent?

Agents negotiate on your behalf. This is helpful, as most people find this very awkward and hard to talk about. It also means you can spend more time on being creative. An agent can also open doors for you with clients they have long-term relationships with. A good agent will also be supportive and give you direction and advice on how to achieve your goals.

Can an influencer have more than one agent?

Yes, you can have an agent in different countries. Usually your main or 'mother' agent will place you with other agencies in other territories with which they have an existing relationship. In regards to having multiple agents in the same country, this is definitely not something that most agencies would allow.

When an influencer is researching potential agents, what should they be looking for?

It is best to meet with them or chat over the phone to get a feel for if they are going to be the right fit for you, as you'll be having a close working relationship. They also need to understand your goals and if they can help you achieve them. It's important to look at who they are currently representing and whether you are the right fit for them as some agencies focus more on beauty while others might have more of a food focus.

When does someone become an influencer and is it just about follower count?

It is more about engagement than just follower count. Your account will have a definite point of difference that makes you stand out from others. You will also have a loyal fan base and, in terms of attitude, will treat yourself as a brand.

What do you look for when taking on a new influencer?

I look at their numbers plus what engagement they have. They need to have a plan for where they are wanting to take their brand moving forward. Are they looking to move into the YouTube space? Do they eventually want to write a book or design a pair of shoes? My clients always want to know what social channels a potential influencer has, so the more the better, as this creates additional opportunities. The possibilities are endless, and because this industry is moving at such a fast pace I want my talent to be on top of their game.

Do you take risks on emerging talent or wait until they reach a certain level of influence?

I have taken on up-and-coming talent such as Indy Clinton, Maxi Hansen and Maia Cotton, as it is always important to look out for the next big thing. I think it is also important to act as a mentor and teach them how to build their brand.

If someone is looking for representation what should they do?

It is important to send through a media kit that includes factual information on your social media channels and, if you have a blog, what the views and unique followers are per month. You also need to give me case studies of any clients you have worked with in the past and why I should take you on. I want to know what makes you stand out from the rest and what your plans are for the future.

And what shouldn't they do?

Definitely do not send an email with just your Instagram name and no real explanation as to what you do and why. To me that is unprofessional and already a bad start as it does not show any initiative, drive or passion for your brand.

What's your one piece of advice for those aspiring to be Instagram famous?

Be true to yourself and don't try and be someone you are not. Everyone has their own creative spirit inside of them so don't hold back! When you feel that you are ready for representation, make sure you are 100 per cent sure about who you go with. Always ask questions and make sure your agent is the right fit for you in terms of your working relationship and be sure that they really believe in you.

Nadine Andrews founded the social-media management arm of Chic Model Management in 2013. Since then she has represented some of the most sought-after bloggers in Australia and worked with clients such as Qantas, E!, Country Road, Net-a-Porter and Estée Lauder.

Be selfie conscious

@LIVPURVIS
Olivia Purvis
Followers: > 120k

If you're anything like me, you might find that selfies sometimes make you feel a little self-conscious. I deal with this by making sure there's a reason for the selfie. Showing off a pair of shades, an item of clothing or a new make-up look that you're loving is always a great place to start. This also injects a bit more of a story behind your selfie, which will inspire your caption. It also creates a good opportunity for you to tag brands and hopefully catch their attention. Just have fun with it and don't take yourself too seriously. If I can do it, anyone can!

Inspiring feeds:
@belleandbunty
@xantheb
@makemylemonade

Olivia's story

I'm Olivia, a 22-year-old style blogger from London. My feed is reflective of my love of food, travel, colours, beauty, music and style. I started my Instagram account alongside my blog about four or five years ago while studying. Back then it was a mix of Hipstamatic filters and badly lit selfies! Now Instagram has become one of my favourite platforms for creative expression, sepia filter or not.

@PHILGONZALEZ
Philippe Gonzalez
Followers: > 270k

Inspiring feeds:
@atfunk
@missunderground
@sejkko

Plan an InstaMeet

It's important to meet your Instagram friends in real life. This builds solid friendships and gives you greater insights into your followers. You can organize an InstaMeet anytime, anywhere, but they're especially good around occasions like Easter, Christmas or Valentine's Day. Start with the logistics. If it's a photowalk, research the route and try to find sponsors to support any costs. Then announce it to the community through your feed and ask your friends and followers to promote it on their accounts. The size of the group shouldn't be too big if it's a photowalk, but at a large venue like a museum there's really no limit. We have had hundreds – even thousands – of people on some InstaMeets!

Philippe's story

I discovered Instagram when it was just a start-up and instantly knew it would change the way we share our lives, meet people and interact with brands. One lazy Sunday I started writing tutorials for early adopters, which became instagramers.com. It caught people's attention and helped them to congregate around the world. Mobile photography has changed my life and the lives of millions of others. Today instagramers.com has over 500 groups in over 80 countries. I wish I had more time to spend on my own account, but as Instagram says, 'community first'. That's something I understood a long time ago!

@PALOMAPARROT
Phoebe Cortez Draeger
Followers: > 320k

Inspiring feeds:
@danlom
@emilyblincoe
@thiswildidea

Find your own style

You can find inspiration in lots of things, such as music, an overheard comment or a moment of fleeting beauty. Edit your Instagram feed like a photobook – if all your pictures have the same aesthetic your followers will feel as though they are on your journey. Find your favourite colours and subjects and stick to them. I like to capture subjects in a very minimal, straightforward way to give my feed a documentary feel. For me this feels more realistic.

Phoebe's story

After studying photography, I couldn't find a job in that area so I started working in a clothing store. In early 2012 a co-worker told me about an app called Instagram. My first-ever post was a picture of my wardrobe, but I quickly discovered my theme and style and my account grew quickly. I had my first Instagram-related job two years later. I have since quit my job as a preschool teacher and now work as a full-time photographer.

Have fun!

People take a lot of things on social media too seriously. At the end of the day, it's important to just appreciate everyone's creativity and explore your own. Humour is a great way to attract attention on Instagram, but at the very least you need to look as if you're having fun. This injects energy into your feed, which people find inspiring. You could create a playfully themed account, write witty captions or document your day-to-day antics. I love running the **@HOTDUDESWITHDOGS** account because, more than anything, it's fun and I get to meet a lot of interesting people.

Kaylin's story

I started an account called **@RICHDOGSOFIG** as a joke and, to my surprise, it actually gained a lot of followers: 25k to be exact. In late 2015 I started thinking about my next social media endeavour. If there's one thing I love just as much as dogs, it's hot guys, so I figured I would put the two together and create the ultimate Instagram eye candy. Having this account has given me a chance to meet some incredible people and I've also been able to support some good causes like animal shelters. I did not start attracting brands until I hit 15k followers and now I am considering finding an agent, as it's a lot of work to manage an account like this!

@HOTDUDESWITHDOGS
Kaylin Pound
Followers: > 395k

Inspiring feeds:
@hotdudesreading
@menandcoffee
@nick__bateman

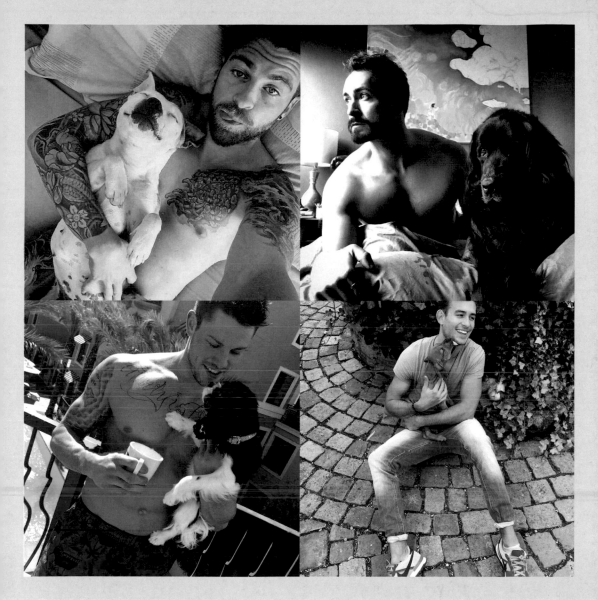

@PANYREK
Kitty de Jong
Followers: > 180k

Inspiring feeds:
@brahmino
@claireonline
@groovypal

It's OK to feel sad

Instagram is perceived as a platform where you must always be having a great day and always be happy. Of course, positivity is empowering, but in life we do sometimes feel sad, and not every day is 'amazing'. It's important to share your genuine feelings with your followers because they have good and bad days, too. I posted this image in response to the 2014 Malaysia Airlines Flight 17 disaster. I was feeling sad and a little disillusioned with the world and I wanted to share that. I think people really engaged with the post because it captured their feelings as well.

Kitty's story

I live in Amsterdam with my husband and our four children. I started using Instagram in October 2011. Having an iPhone camera with me all the time meant I started photographing more, and early on I gave myself the challenge to only post iPhone photos. In the beginning, Instagram took up a lot of my time, as I was always looking out for locations, subjects and beautiful light. I would also spend time browsing through the app for great photos by other photographers. I learned a lot from them and it inspired me to go out even more.

Instagram dos

Talk to your followers, reply to their comments and comment on other people's pictures.

Credit or mention brands and fellow Instagrammers. Tag them in your photos or captions.

Take your time and use editing apps so your pictures look perfect before you post.

Create a consistent tone or style. Followers love a feed that flows beautifully.

Delete old images as your style evolves. You'd be surprised at how far back people will scroll through your feed!

Keep your profile information up to date with all your additional social media platforms and links to websites or blogs.

Use geotags to show your followers where you are/were. Geotagging your neighbourhood is also a good way to build a local following.

Go to organized InstaMeets to build more personal relationships with the community.

Write engaging captions to add another layer of interest to your pictures.

Add a touch of sharpening to all your images, as this helps them maintain clarity after being uploaded.

Instagram don'ts

Use other people's images without crediting them. This will get you reported and you'll be blocked from using the app.

Forget to write captions alongside your post, as this makes for less engaging content.

Post too many images per day. Aim for two or three max and spread them out.

Post any photographs of anyone's private parts. This might get you a few hundred followers over a couple of hours, but then you'll be blocked from using the app.

Use too many hashtags. One or two well chosen hashtags is enough. If you really have to use more, post them in a comment so they are not so visible.

Follow too many people. Your feed will become full of posts that don't inspire you. This also puts people off following you because you look a bit 'loose'.

Use old-school filters. Really, just don't.

Post an image and then stare at your phone waiting for likes. Instead, go out and look for other photo opportunities!

Pay for followers. You won't fool anyone because your engagement will be so low compared to your follower count.

Lose friends by constantly snapping things when at lunch. Plan your time well so you give yourself time off.

Credits

Acknowledgements

A big thank you goes to the following for all their invaluable
help and hard work: Sara Goldsmith, Alex Coco, Jess Angell,
Nia Pejsak, Nadine Andrews, Ruby Grose, Susie Macintosh,
Anna Pihan and all the fantastic contributors.

About the researcher

Jess Angell fell in love with Instagram in early 2011 and soon
founded a community of Instagram users in London who
regularly do InstaMeets and contests. Having reignited her
passion for photography, Jess changed careers and became a
full-time Instagram Consultant in 2013. She now works with
many brands and companies who want to learn about Instagram
or improve their content and account, and her work has given
Jess the opportunity to travel around the world meeting amazing
Instagram users who are now great friends.
Jess has two successful Instagram accounts,
@MISSUNDERGROUND and **@MISS_JESS**.